ISAMU NOGUCHI

ISAMU NOGUCHI SPACE OF AKARI & STONE

CHRONICLE BOOKS

First published in the United States 1986 by Chronicle Books

Copyright© 1985 by The Seibu Museum of Art. All rights
reserved. No part of this book may be reproduced in any
form without written permission from the publisher.
First published in Japan by Libroport Co., Ltd.
Printed in Hong Kong

All works, text p. 14 and "The Meaning of Akari":
Copyright© 1985 Isamu Noguchi
"The Theater of the World in a Garden":
Copyright© 1985 Takahiko Okada
"To Envision a Living Space" and drawings pp. 89, 102:
Copyright© 1985 Arata Isozaki
Cover photograph and photographs
pp. 15, 17-24, 26-27, 30-31, 33, 36-37, 40, 41,
44-45, 48-56, 58-59, 62-63, 66-67, 70-71, 73-85:
Copyright© 1985 Shigeo Anzai

Book design by Ikko Tanaka and Katsuhiro Kinoshita

Library of Congress Cataloging-in-Publication Data:

Noguchi, Isamu, 1904–1988
Isamu Noguchi, space of akari & stone.

Catalog of an exhibition organized by The Seibu
Museum of Art
Title in Japanese on added t.p.: Isamu Noguchi ten,
akari to ishi no kukan.
1. Noguchi, Isamu, 1904–1988 -Exhibitions.
2. Lighting, Architectural and decorative-Exhibitions.
I. Seibu Bijutsukan. II. Title. III. Title: Space
of Akari & stone. IV. Title: Space of Akari and stone.
V. Title: Isamu Noguchi ten, akari to ishi no kukan.
NB237 .N6A4 1986 709' .2'4 86-13623
ISBN 0-87701-405-1 (pbk.)

Distributed in Canada by Raincoast Books
8680 Cambie Street, Vancouver, B.C. V6P 6M9

10 9 8 7 6 5

Chronicle Books
85 Second Street
San Francisco, California
94105

www.chroniclebooks.com

Contents

The Theater of The World in a Garden—Takahiko Okada 7

Space of Akari and Stone .. 17

Poster for the Exhibition—Ikko Tanaka 88

To Envision A Living Space—Arata Isozaki 91

The Meaning of Akari—Isamu Noguchi 95

List of Works .. 97

The Theater of The World in a Garden Takahiko Okada

In 1984 and 1985 we were privileged to have exhibitions by Isamu Noguchi. I say privileged because chances to see his actual works have been all too few, even though his name is well known here and his roots go deep in Japan. These particular works evidenced a reawakening of childhood memories and youthful sensibilities, summing up all phases of his creative expression thus far. Typically, when artists make a return to childhood and youth after long years of exploring in one direction, the result is a certain sentimentalism, emotionally illuminated with sheer absorption in the self, but falling short of true rigor in the concrete crafting. Not so with Noguchi: he did not get caught up in the hauntings of the past, but rather brought the vision of his youth to yet higher, and if anything, surer concrete expression. His creative abilities showed no sign of decline, unlike so many others.

In 1984, in the interior garden *Tengoku* [Heaven] that he himself had designed in 1977 for the first floor of the Akasaka-area Sōgetsu Kaikan in Tokyo, Noguchi held a showing of twenty-six editioned metal sculptures made by immersion-plating old steel materials in molten zinc. While this series of sheet-metal works may well relate to his bent sheet-metal *Leda* of 1928, or to his unique spatial constructions of the 1940s that clearly matured from Constructivist open form influences, probing even further back, they spoke of childhood memories of working with paper. Undeniably, the many-legged voyage of self-discovery had at length brought a rebirth in the form of these extremely concise, yet moreover humorous works. Then in 1985, in the first comprehensive showing of his Akari lamp series at the Yurakucho-area Art Forum in Tokyo, there was no mistaking how Noguchi's love of Japan had fused with his own formative genius. Also on view at the same time, his recent stone sculptures achieved striking simplification while harking back to the summative spatial concept of the "garden," perhaps Noguchi's own greatest theme. Both the translucent Akari lamps floating in space and the ponderous stone sculptures, however different in character, were natural expressions of Noguchi's spatial perceptions. In form and style, Noguchi has continually managed to keep one eye on the heart of enduring past traditions, while simultaneously attending to the more timely spatial ideas of the present. In this we recognize what he himself has said—in the progressive mode—of his own activities:

I am always looking for a new way of saying the same thing.

(quoted in Sam Hunter, *Isamu Noguchi-75th Birthday Exhibition*, 1980)

All fourteen stone sculptures shown at this time were very recent works produced in 1984 and 1985. As indicated by the symbolic title of two of these pieces, *Shizen no Henka* [Transformation of Nature], rather than any unnecessarily complex distortion of the stone, these directly carved stone sculptures followed the natural inclinations of the material, adding only the minimum of finishing touches to bring out latent shapes and qualities. I see this as a trend that has grown ever stronger in his work since the latter half of the 1960s. This simplicity capable of generating such dynamic reactions and far-reaching emotions in viewers, form so primal it takes in everything around it, emerges as a

conscious pursuit from around when he made intensive study of traditional Japanese *kare-sansui* "dry landscape" gardens toward his designs for the UNESCO Headquarters Gardens (1956-58) in Paris. To be sure, his firm rejection of the extraneous as a unifying means of getting to the purest source of things dates from early on in his youth. This came as the joint result of a self-recognition of his Japanese parentage on the one hand and the decisive influence of Constantin Brancusi on the other, all of which found clear focus over the course of actual creative expression. His experience as an assistant to Brancusi for a two-year period from 1927, during which time he was hardly conversant in French, seems to have taught him through his body, hands and eyes much of his basic stance.

He affirms just that in the following statement:

Brancusi, like the Japanese, would take the quintessence of nature and distill it. Brancusi showed me the truth of materials and taught me never to decorate or paste unnatural materials onto my sculptures, to keep them undecorated like the Japanese house.

(quoted in Sam Hunter, *Isamu Noguchi*, 1978)

It was Brancusi's honesty toward his materials while reducing things to their formal essence that turned Noguchi's young eyes toward a basically Japanese view of nature. And of course, without such grounding his recent sculptures would not have come about. Starting from this grounding, his work has taken many turns until now at long last he finds he can leave much up to nature, allowing his stone sculptures to concentrate into lean and terse forms that invite free imagining.

Wood and stone, naturally enough, differ in their intrinsic qualities from metal, plastic and other materials. Noguchi himself has touched upon this in relating his basic stance toward wood and stone:

Sculpture may be made of anything and will be valued for its intrinsic sculptural qualities. However, it seems to me that the natural mediums of wood and stone, alive before man was, have the greater capacity to comfort us with the reality of our being. They are as familiar as the earth, a matter of sensibility. In our times we think to control nature, only to find that in the end it escapes us. I for one return recurrently to the earth in my search for the meaning of sculpture—to escape fragmentation with a new synthesis, within the sculpture and related to spaces. I believe in the activity of stone, actual or illusory, and in gravity as a vital element. Sculpture is the definition of form in space, visible to the mobile spectator as participant. Sculptures move because we move.

They say in Japan that the end interest of old men is stone—just stone, natural stone, ready-made sculptures for the eyes of connoisseurs. This is not quite correct; it is the point of view that sanctifies; it is selection and placement that will make of anything a sculpture, even an old shoe. (Isamu Noguchi, *A Sculptor's World*, 1968)

In a very real sense, Noguchi embodies an awareness born of the Japanese tradition, yet he relies just as strongly on his own eyes and physical faculties to help him draw out the living essence latent in wood and stone. More than anything, this multi-faceted sensibility stems from his unique background: born in Los Angeles, the son of writer Leoni Gilmore (her mother, his grandmother, reputedly part Native American) and poet Yonejirō "Yone" Noguchi, his Japanese-American heritage was the source of considerable hardships while growing up. More precisely, his drive toward self-expression and self-determination was spurred by such misfortunes as his parents' divorce early in childhood and the heart-rending antagonism of the World War II years.

In his introduction to *A Sculptor's World*, Noguchi's close friend of many years, Buckminster Fuller, described him.

Unaware that the absolute political sovereignties of yesterday's world were to melt and merge into a unitary cosmos, Isamu travelled on and on, not as a tourist, not as a dilettante escapist, not as a routine airline pilot, nor as sailor, soldier or gypsy, but as the intuitive artist precursor of the evoluting, kinetic one-town world man.

(quoted in Isamu Noguchi, *A Sculptor's World*, 1968)

He also saw his personal stature in the following light:

Unquestionably, the remote and complex cross-breeding of Noguchi's European-Asiatic-American genes defied his conscious urge to settle down. I first met Noguchi when I was thirty-two years old—I am now seventy-two—and I recall his stated envy of the natives of various lands who seemed to him to 'belong to their respective lands.' As with all human beings, he had the deep yearning for the security of 'belonging'—if possible to a strong culture or at least to some identifiable social group. Despite this yearning it proved biologically and intellectually impossible for him to escape his fate of being a founding member of an omni-crossbred world society. (quoted in Isamu Noguchi, *A Sculptor's World*, 1968)

Notably, Isamu Noguchi's diverse ancestry enables him to look on the Japanese tradition objectively while at the same time bringing that tradition to new realization. Here, then, is where he derives his truly contemporary perspective. The aforementioned meeting with Brancusi thus seems to have served as a catalyst, bringing together Noguchi's free spirit with his quest for identity, and ultimately giving rise to the works of his later career.

Indeed, it is Noguchi's ability to digest and utilize these diverse elements in his own personal background that makes for the eloquently multivalent spatial perceptions so characteristic of his works. Noguchi holds that sculpture consists in the very act of giving order and meaning to the unseen flux of space. As early as 1946, he opened his statement in the catalogue of the New York Museum of Modern Art's *Fourteen American Artists* exhibition with the words:

The essence of sculpture is for me the perception of space, the continum of our existence.

(Isamu Noguchi, *A Sculptor's World*, 1968)

Long after that, he again wrote:

I am excited by the idea that sculpture creates space, that shapes intended for this purpose, properly scaled in a space, actually create a greater space. There is a difference between actual cubic feet of space and the additional space that the imagination supplies. One is measure, the other an awareness of the void—of our existence in this passing world.

(quoted in Isamu Noguchi, *A Sculptor's World*, 1968)

One aspect of Noguchi's multivalent spatial perceptions resides in the "internalized wilderness" of humans living close to nature, yet speaks through the universalized formative language of city dwellers. No doubt his own ingrained sense of the wild dates from his impressionable youth when he first experienced American life at a "learn-through-doing" school in rural Indiana. Another aspect has to do with his identifying the study of contemporary sculpture with self-discovery, their interpenetration. At this juncture, the insistence that sculpture is not limited to volumetric objects, but is also to be found in the realization of the properties of intangible time and light, a notion that has much to do with the mutual

relationship between being and non-being in traditional Japanese forms of expression. This attention to the interplay of being and non-being becomes especially clear in his designs for gardens, where gravity is "taken as a metaphor to clarify the meaning of our uncertain and unsettled existence."

His series of Akari lamps clearly represents a near-pure form of this thinking, the almost physically weightless qualities of *washi* papers letting light itself shape spatial perception. However, even more multivalent spatial perceptions are concentrated in his gardens. His first move in this direction came in 1933 with his playground *Play Mountain*. Then gradually, as his gardens developed through a growing appreciation of the Japanese *kare-sansui*, his very conception of what constitutes a garden became more all-inclusive—and for me, much more engaging. At the same time, I see this thinking as central to his recent related *Table Landscape* series. Noguchi has said that:

> *In Japan the rocks in a garden are so planted as to suggest a protuberance from the primordial mass below. Every rock gains enormous weight, and that is why the whole garden may be said to be a sculpture, whose roots are joined way below.*

(Isamu Noguchi, *A Sculptor's World*, 1968)

Noguchi thus rejects any mechanically ordered approach to composition in favor of the out-branching image of the Japanese garden, where an underlying primal root informs an infinite whole. This, he points out, is the common ground of his gardens and sculptures. As he reaches ever keener awareness of the intimate relationship between each and every sculptural work and the infinitude of space, his works have come to more truly reflect this all-inclusive potential. Clearly, this is what links his gardens and tables.

> *If my tables now suggest landscape, you must be aware that every garden is a landscape, and every garden can be considered a table, too, especially Zen gardens. Some of them we call* kare sansui, *which means "dry riverbed," because they use conventions of gravel and rocks. The garden of Ryoanji has another convention of raked sand with rocks to suggest the sea. In my tables I don't use gravel or sand, but I use a flat area of stone which is more or less their equivalent. You can say every garden in Japan is an altar, in a sense, but an altar is a kind of a table, too. An altar is specifically used for ritual, having to do with the Godhead in Christianity. Then, there are other kinds of altars—the Altar of Heaven in Peking was used for emperor worship. There are all sorts of correlations between tables, gardens, plazas and ritual. Every time we have a meal, it used to be that people would invoke thanksgiving of some sort. The Japanese won't start eating without saying, "I am partaking."*

(quoted in Sam Hunter, *Isamu Noguchi-75th Birthday Exhibition*, 1980)

Who else but Noguchi could have taken the common "table," something we generally give little thought to, but which has a vast cultural anthropology all its own, and elicited works on the order of his *Table Landscape* series? Here he has voided the table, so long overlooked by modern sculpture, turned it into a level stone plane like his gardens, and brought forth a boundless expression of nature. Here he has given our drifting existence grounds, he has given us a place we are joined together. Moreover, as indicated by the origins of his first prototype of the *Table Landscape*, his *Yoru no Kuni* [Night Kingdom] (1947) derived from the stage setting for the Martha Graham ballet *Night Journey*, these works act to bring all those around them into a theater of participation. Thus, in the largest sense, the stone sculptures of Isamu Noguchi, so garden-like in their quietude, set a stone stage for the theater of the world.

Big is small — small is big
Small room — big AKARI — tall stand small
Ceiling AKARI
 surprise.

High low small big
Very high very low — on floor
on table — without base

Then yoshizu — wool panel
in box in corner —

on tatami on wool — old
new — egg crate — papier cartou

on glass — mirror in mirror
on stone — gravel — sand-rocks
in grass — pampas
in bamboo — on peg —

a metaphor — shoji
bed side — futon side
flower side — tree — cloth
silk — gold — alluminum foil.

tea — ikebana —

Nov 17 84
On un birthday
To Isozaki

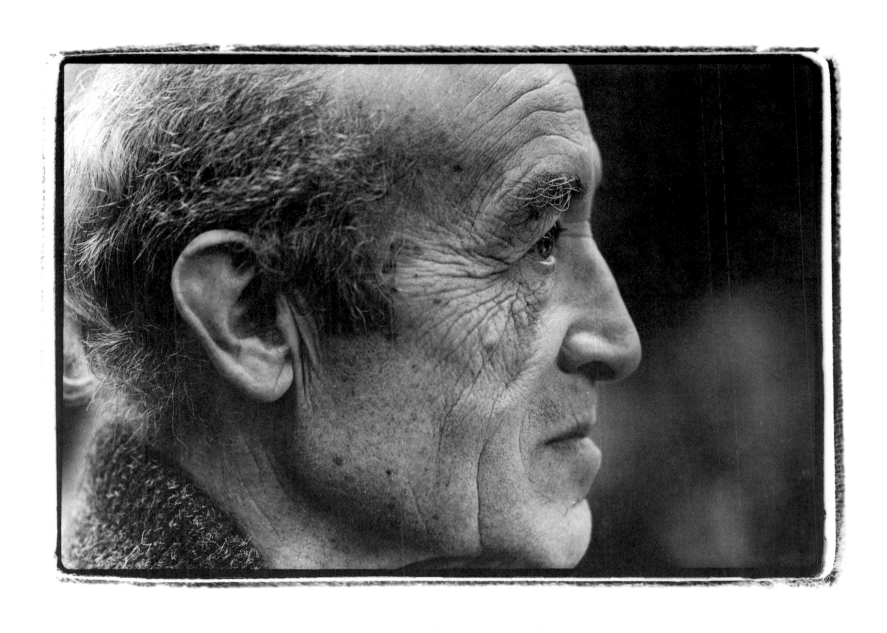

Photo by Shigeo Anzai

Photographer ·········· Shigeo Anzai
Photographer ·········· Yasuyuki Ogura

Book design
Art direction ············ Ikko Tanaka
Design ····················· Katsuhiro Kinoshita

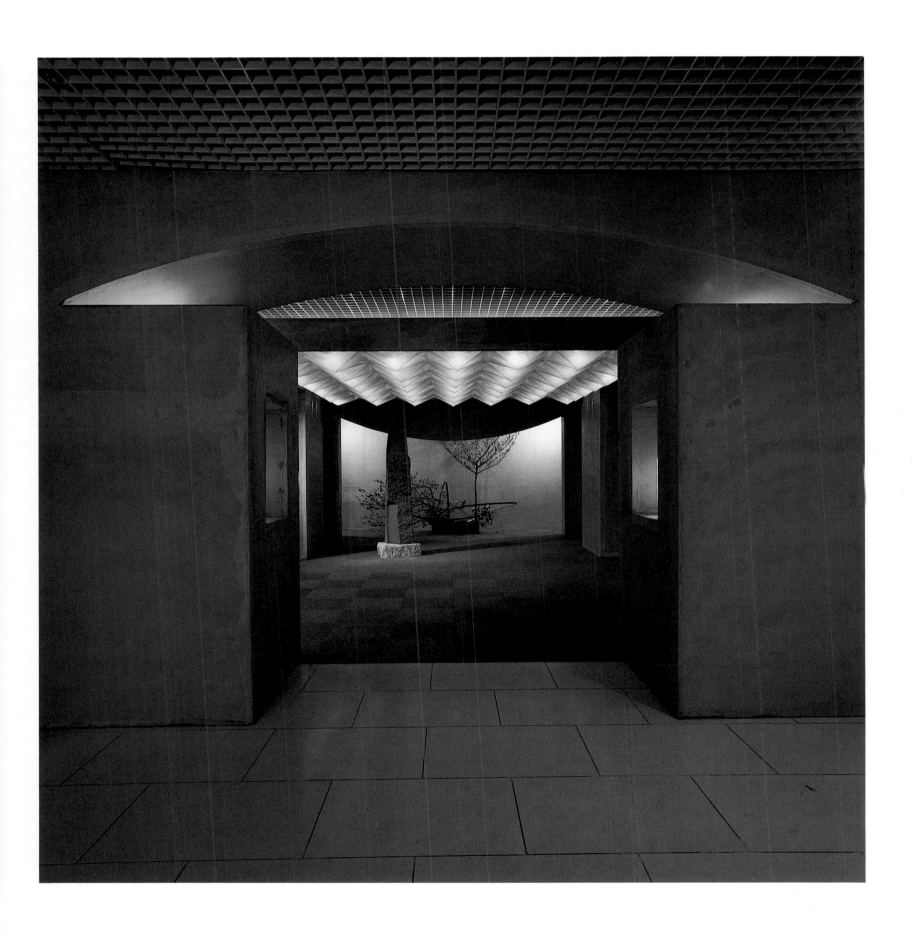

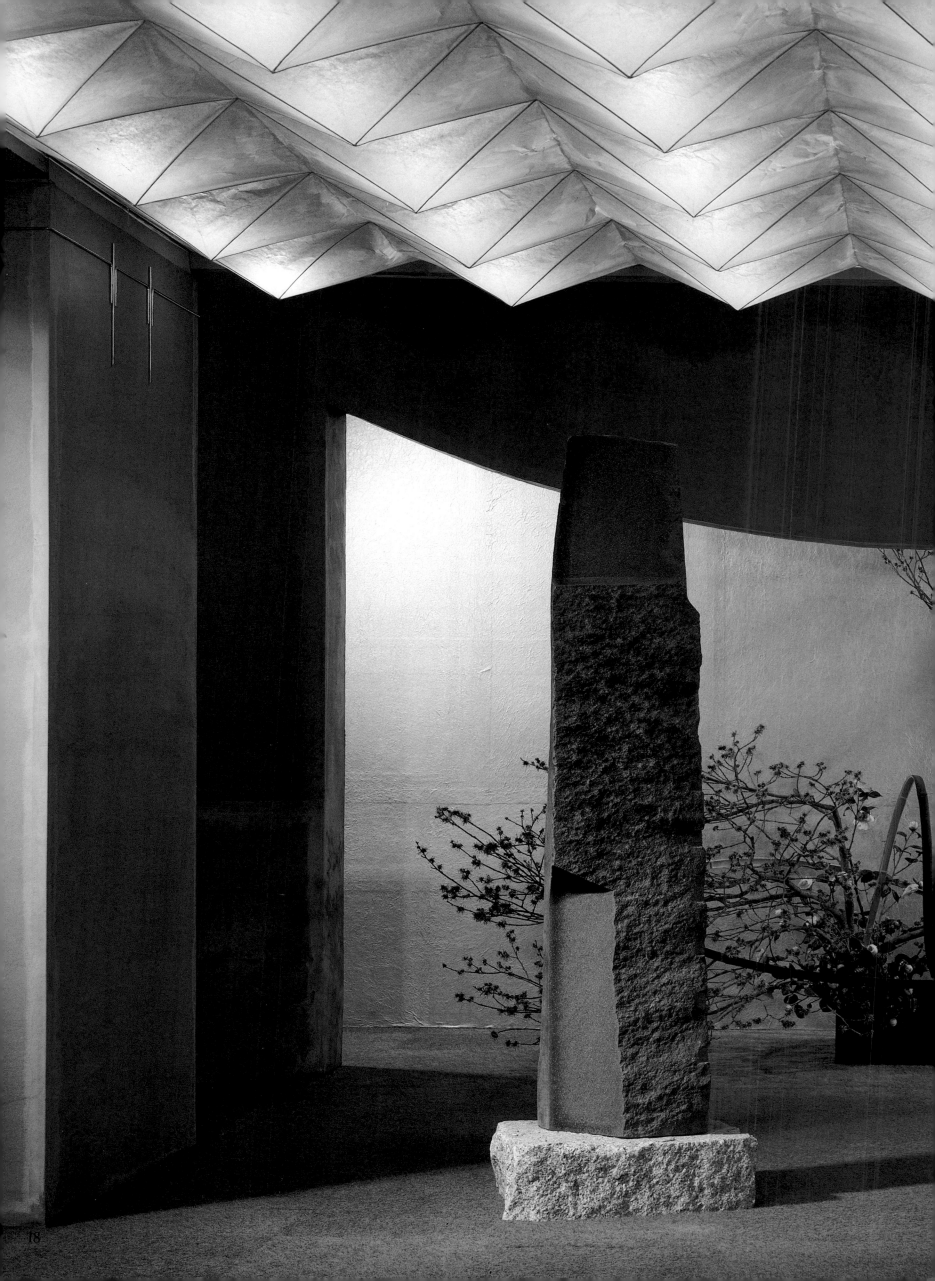

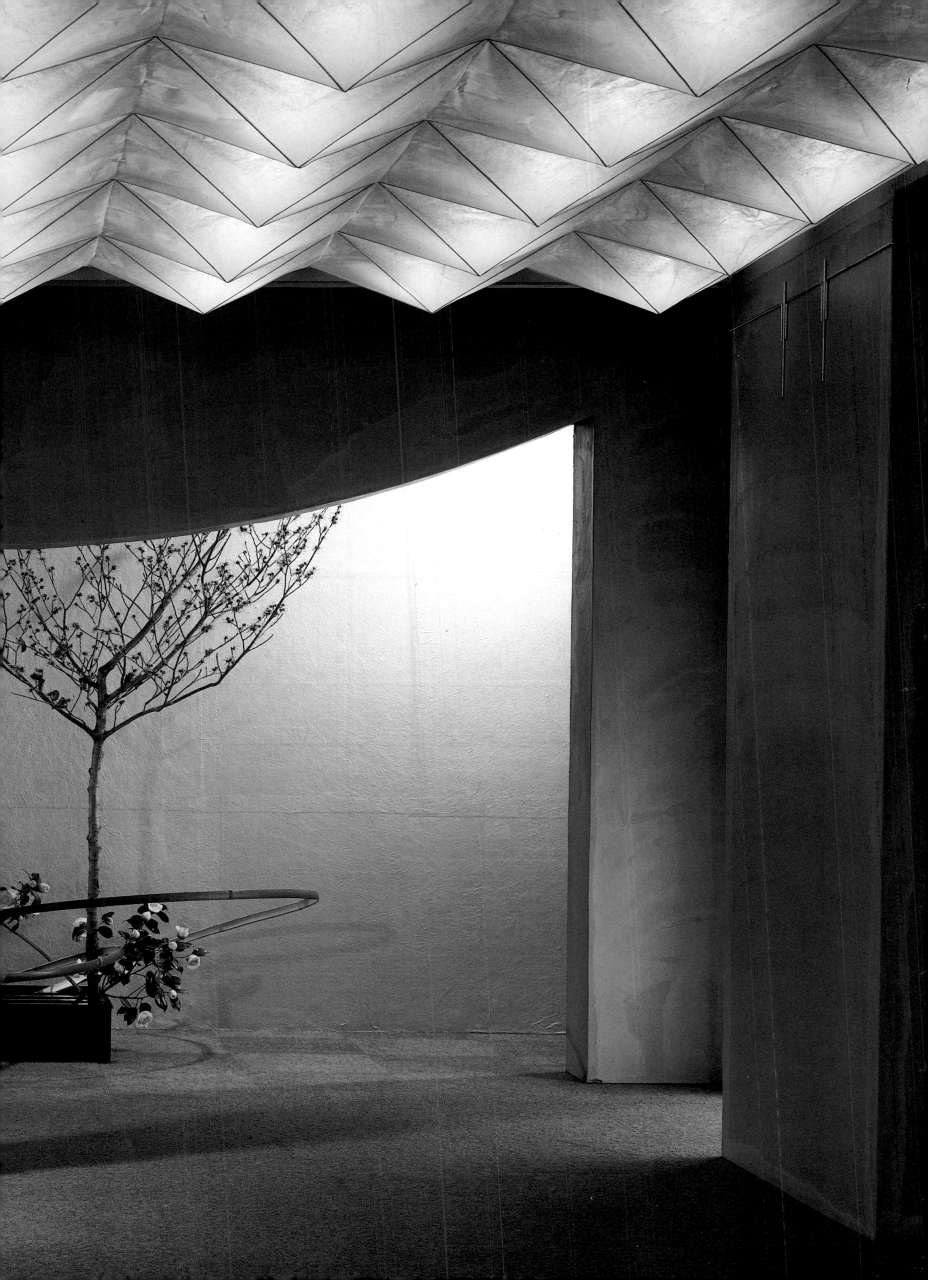

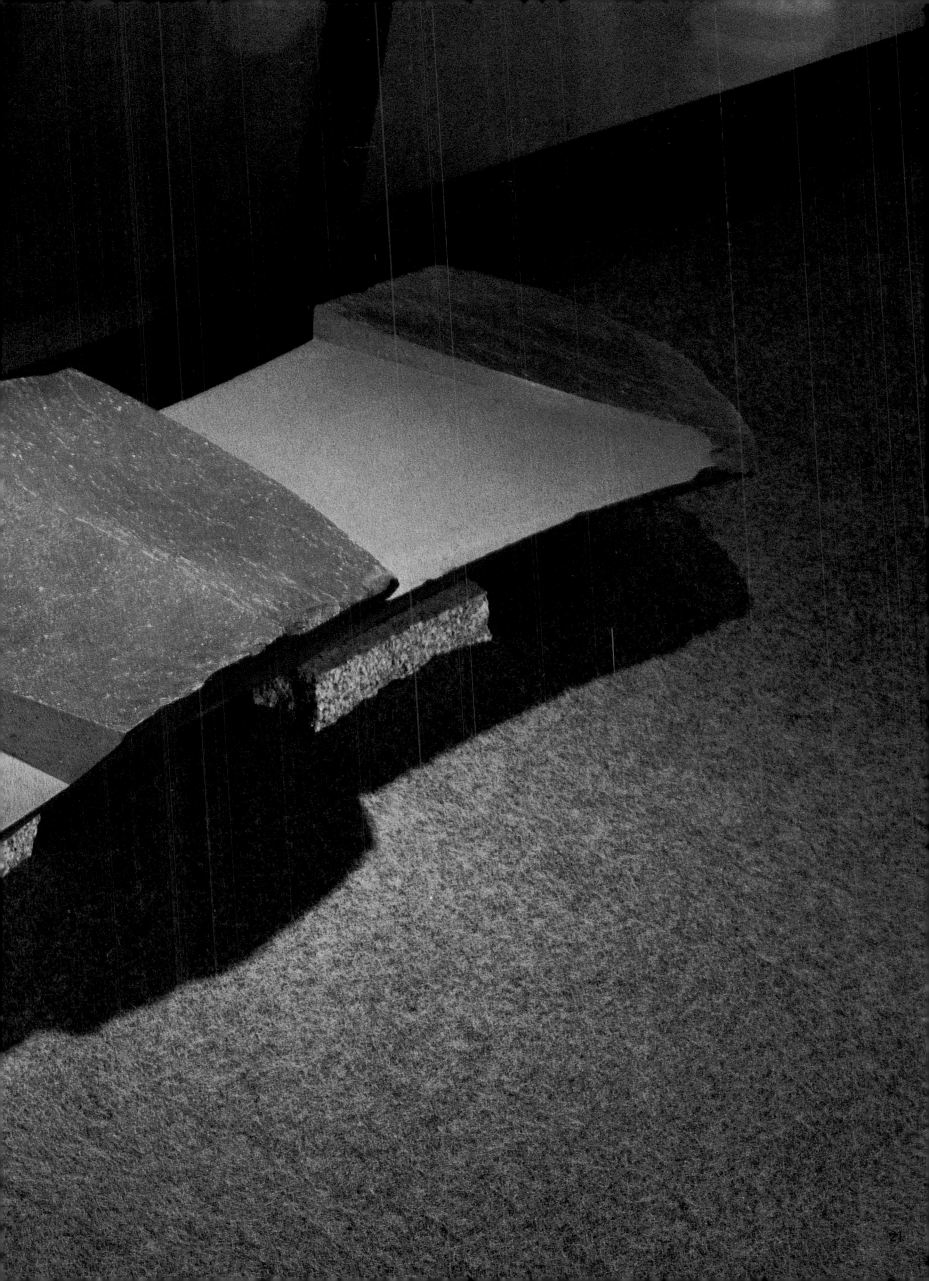

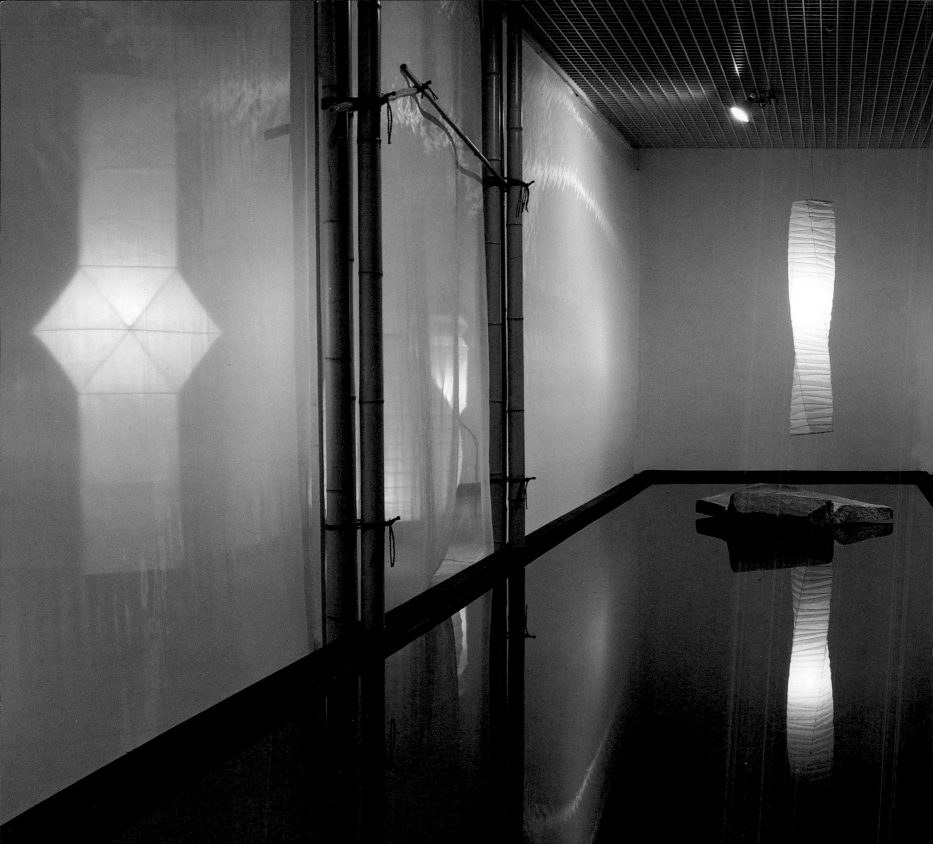

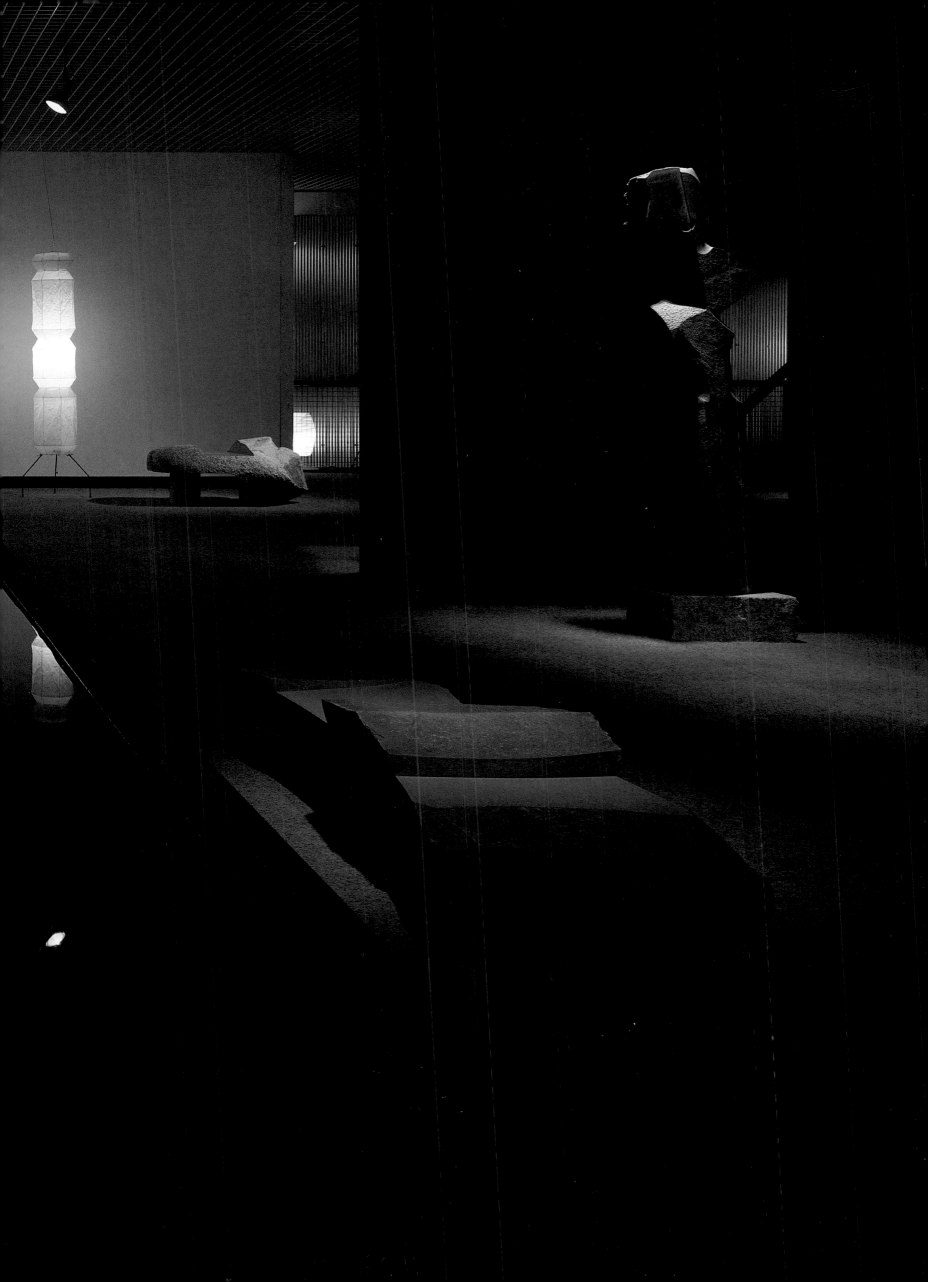

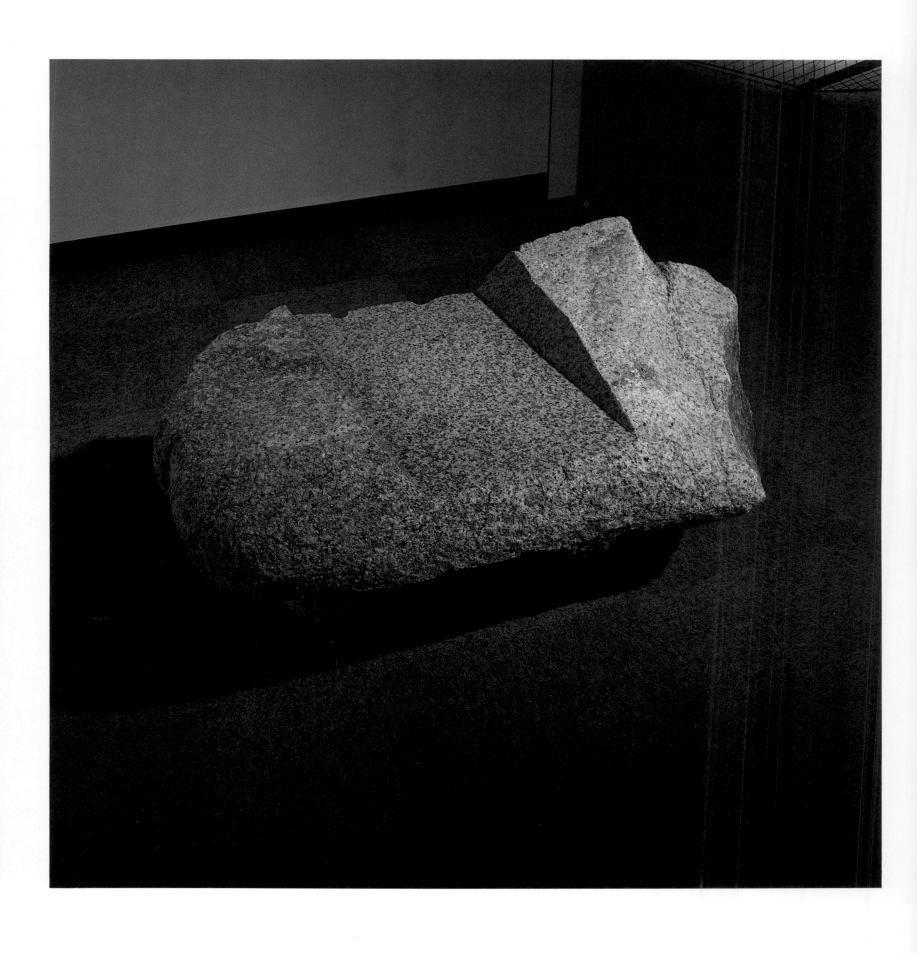

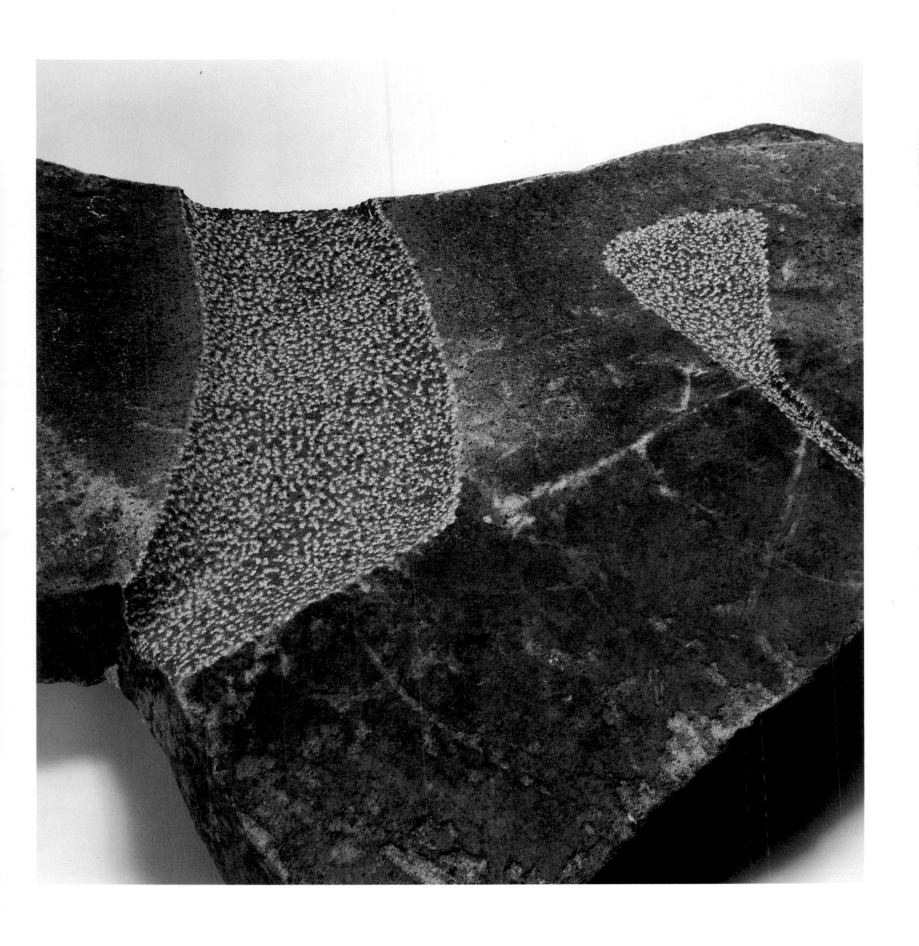

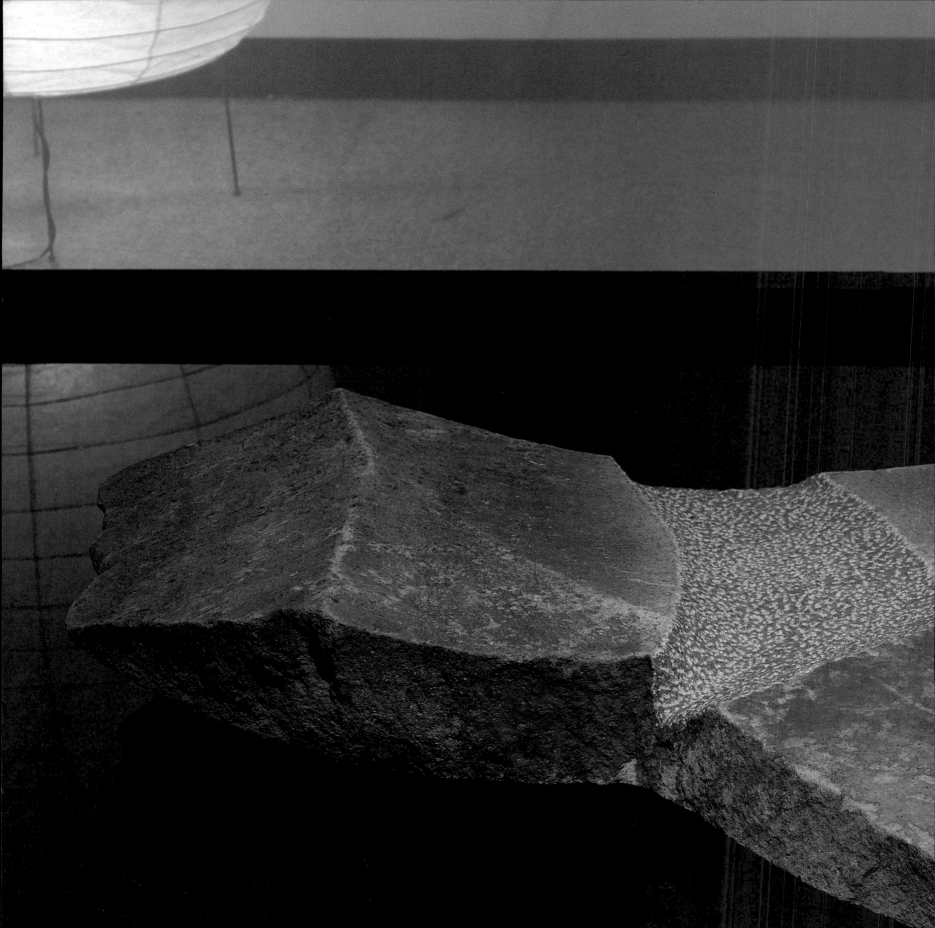

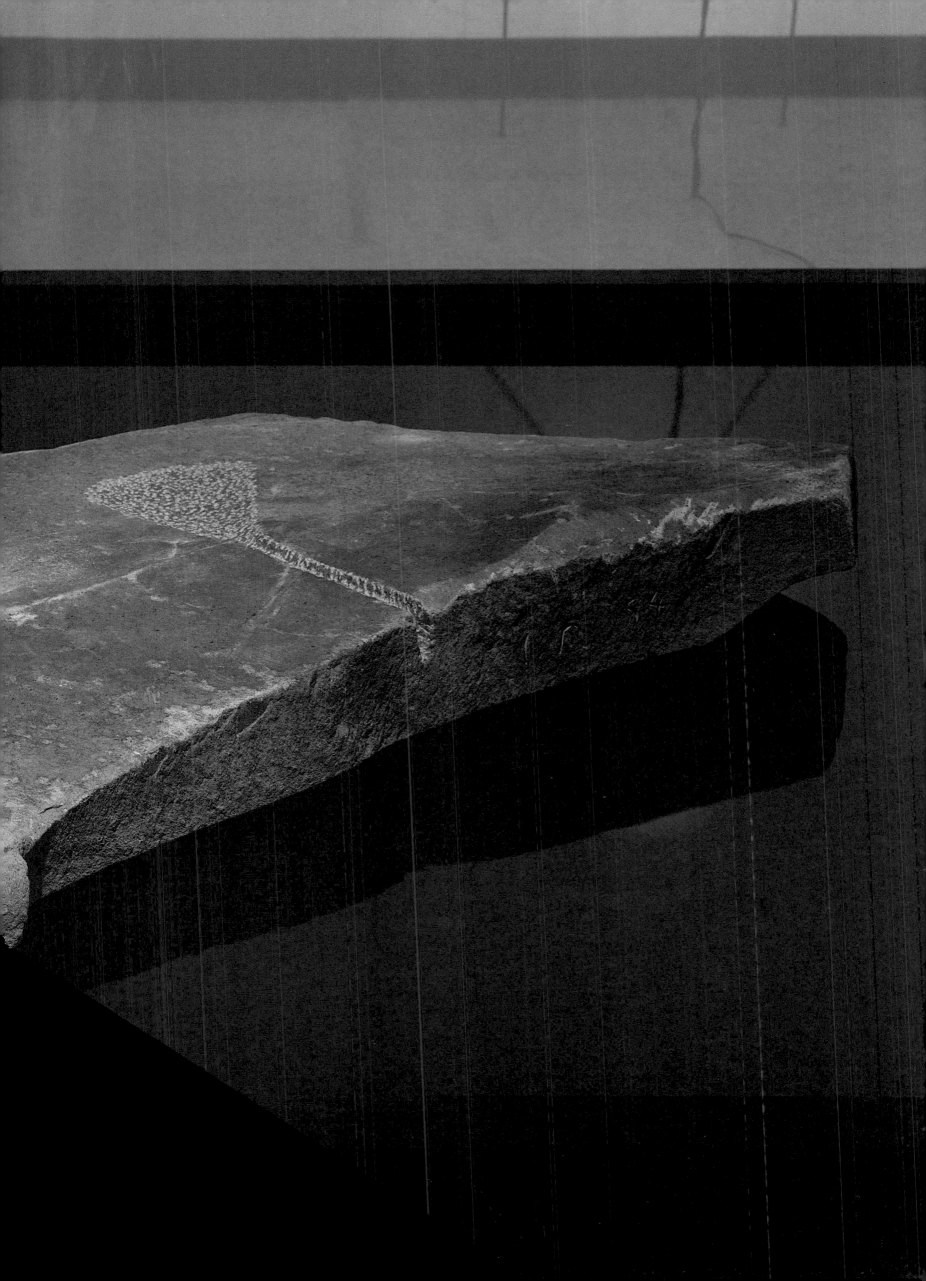

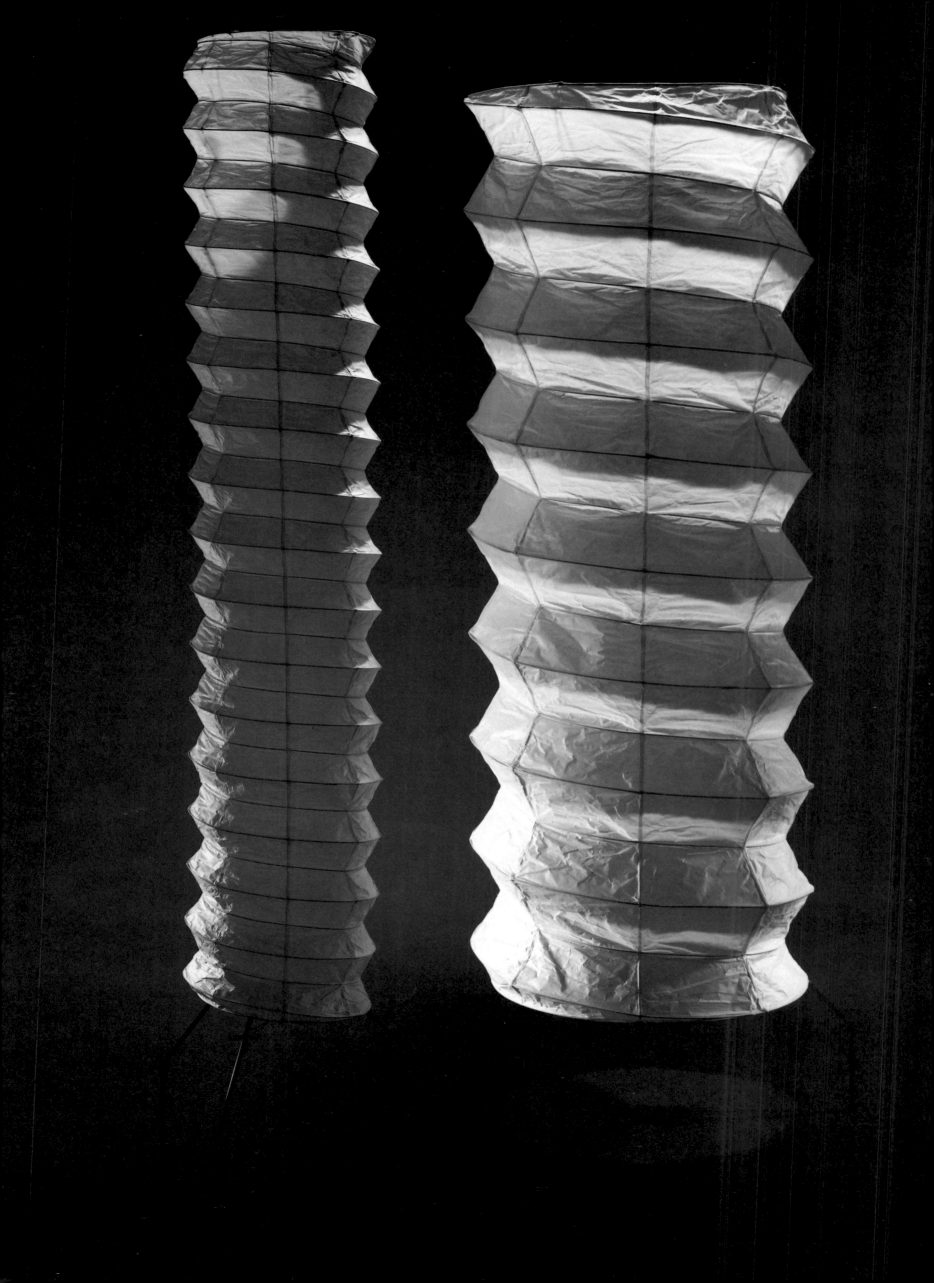

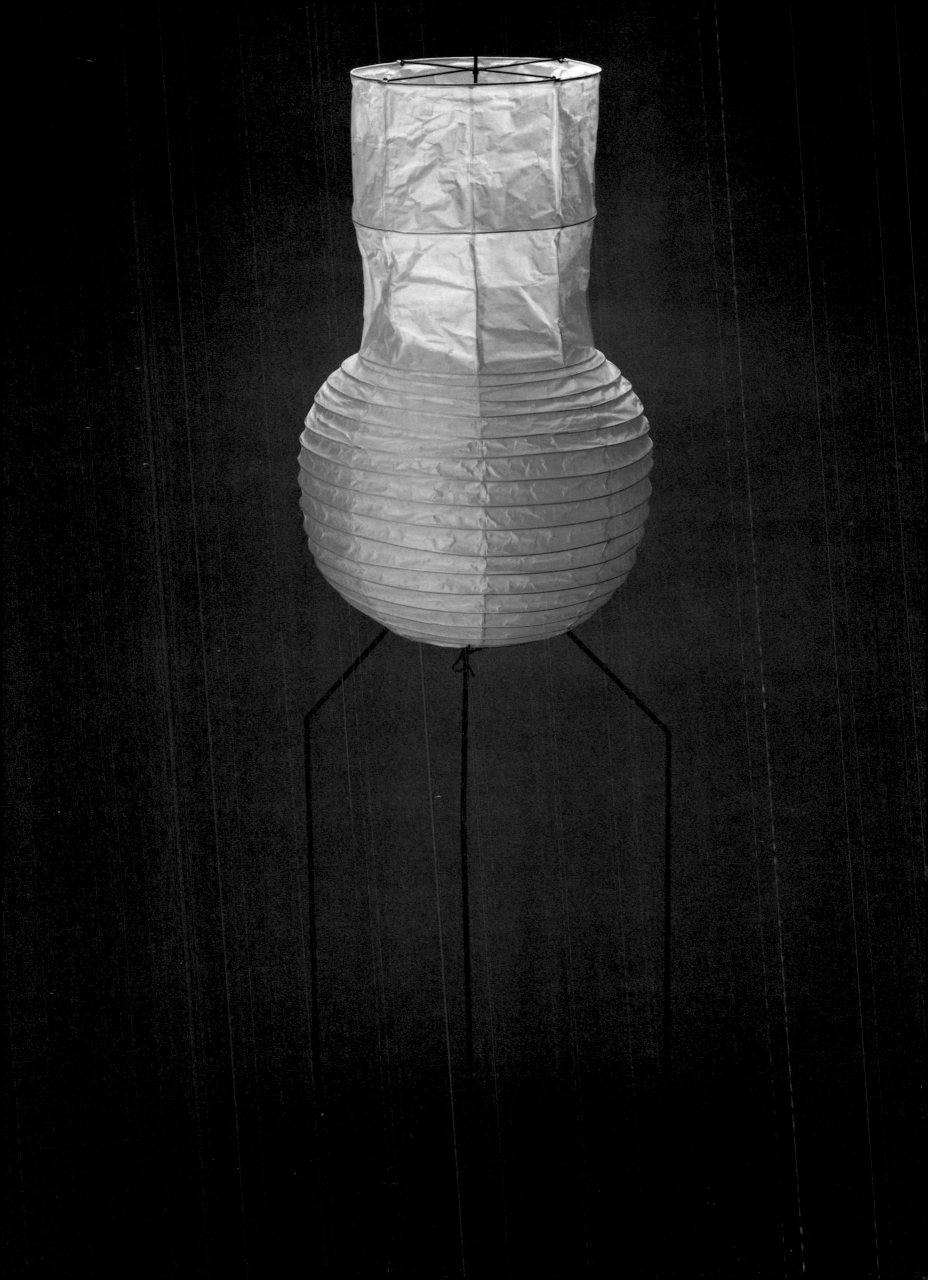

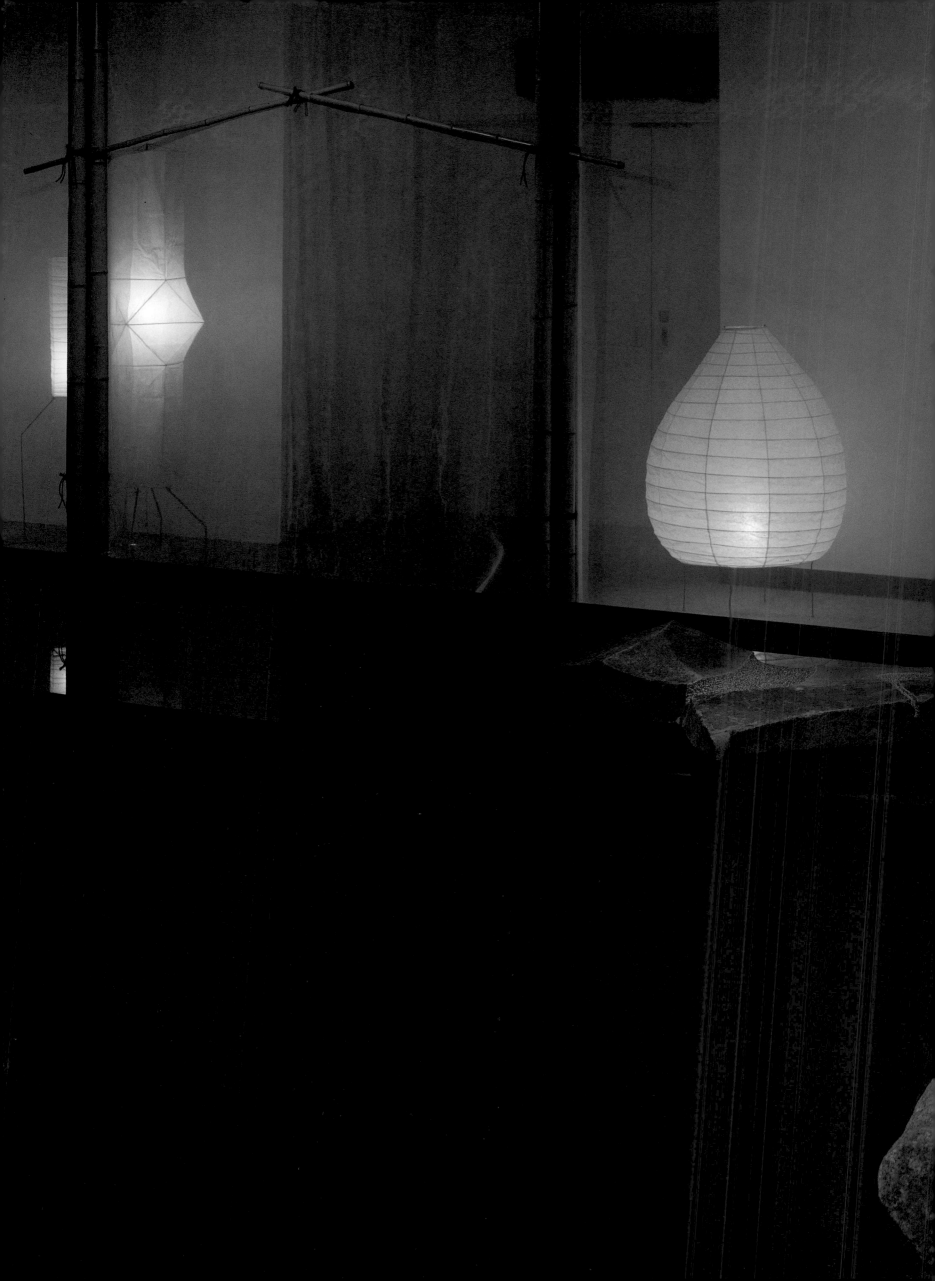

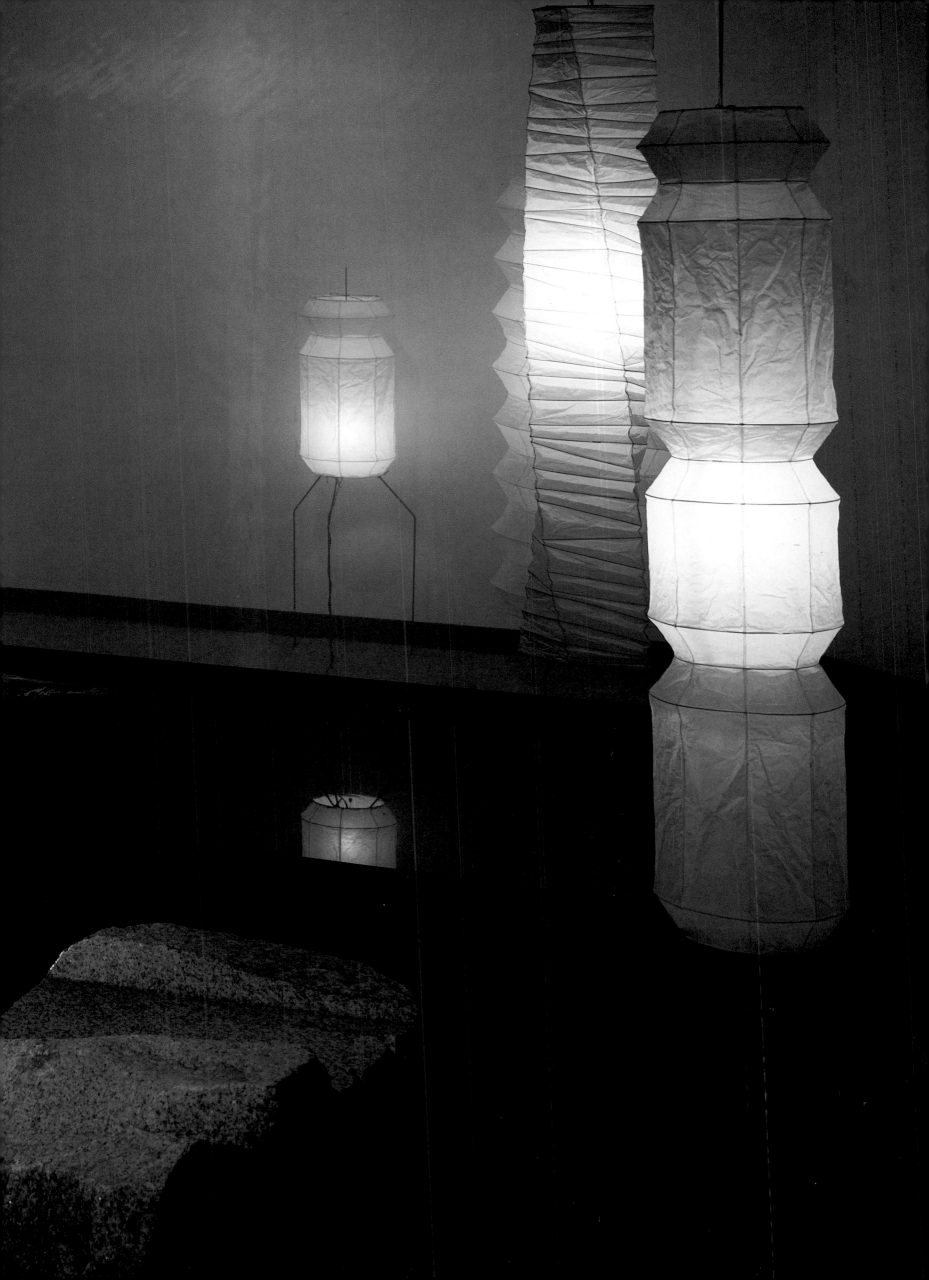

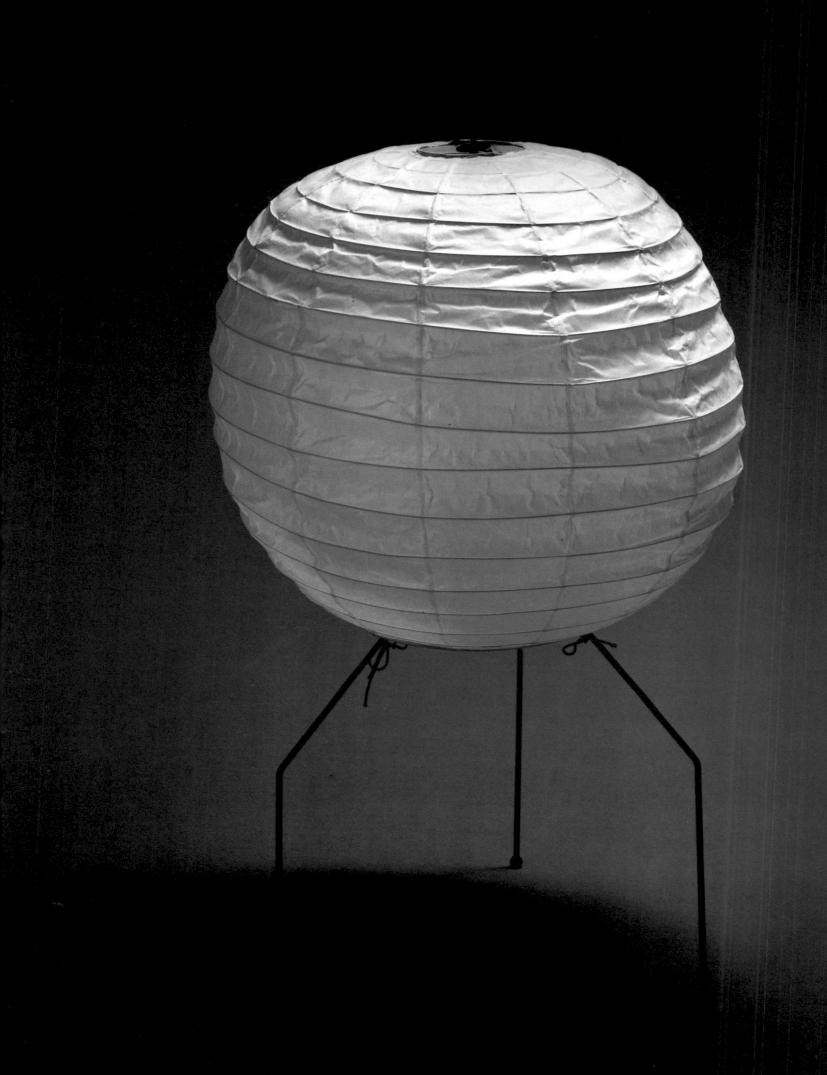

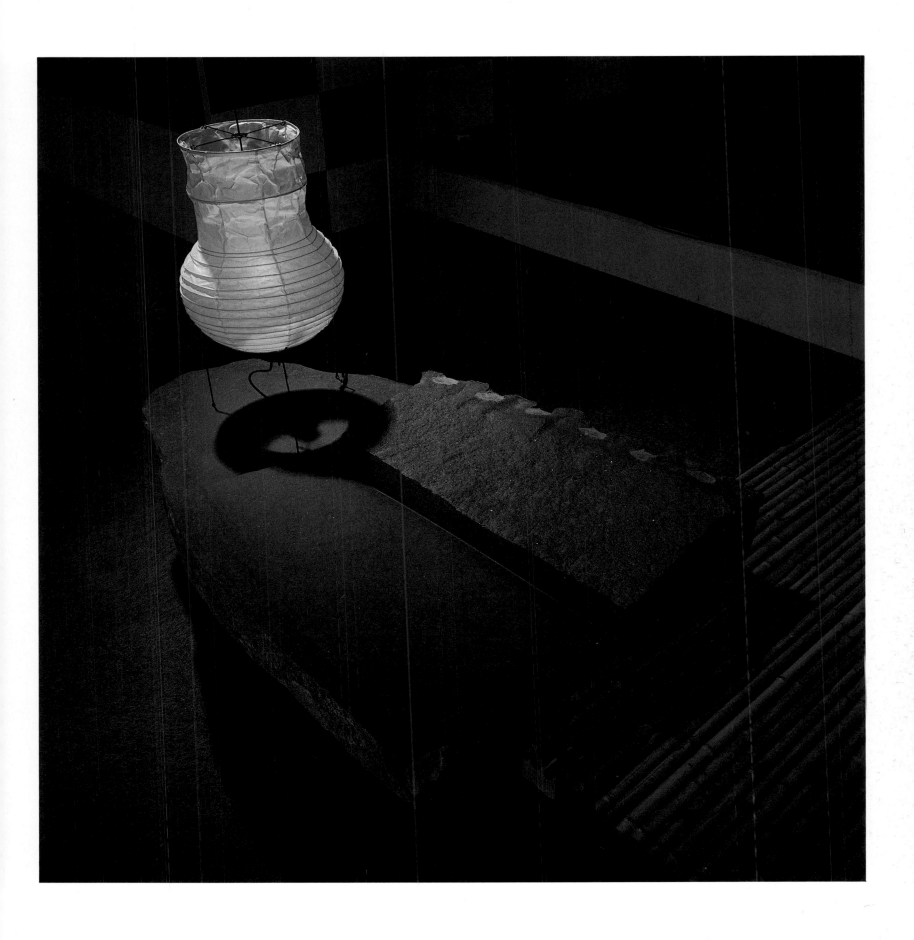

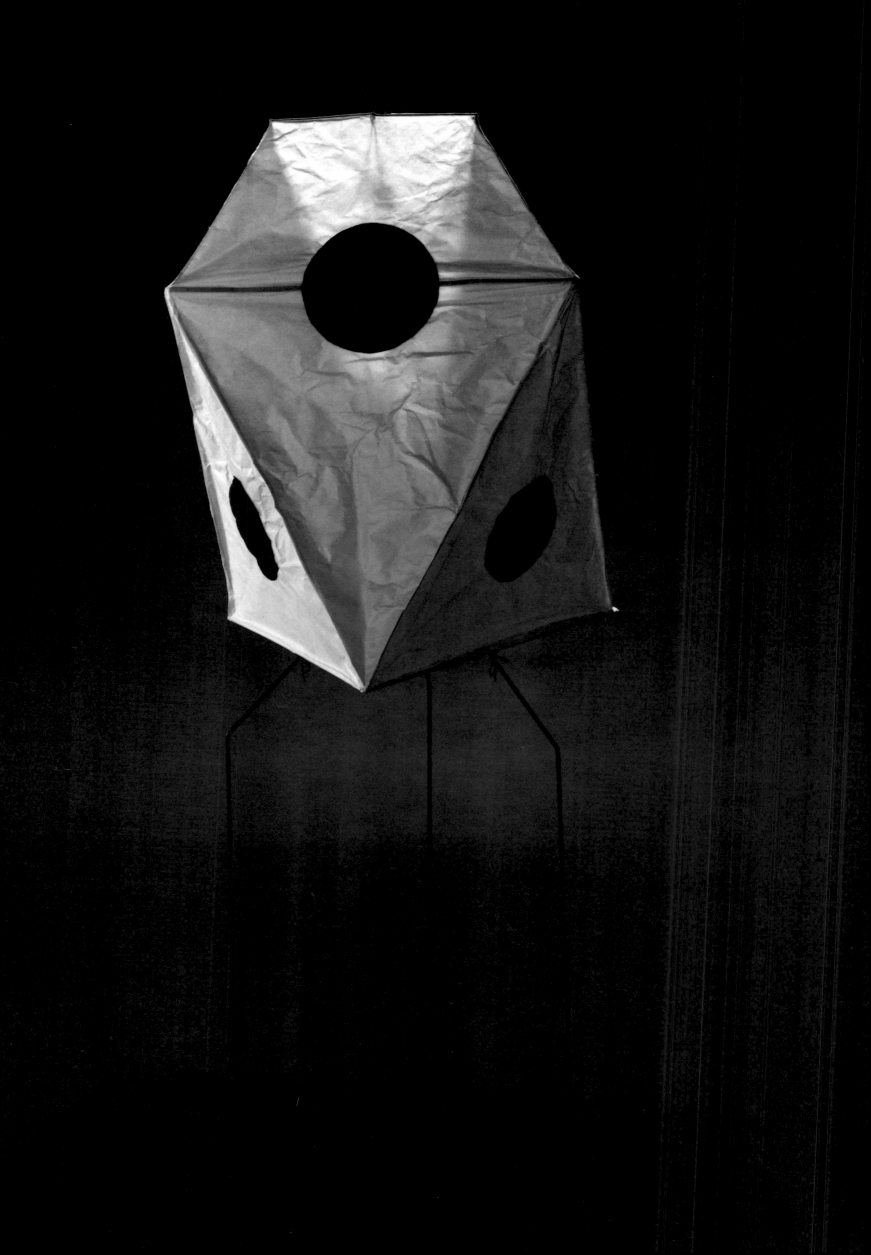

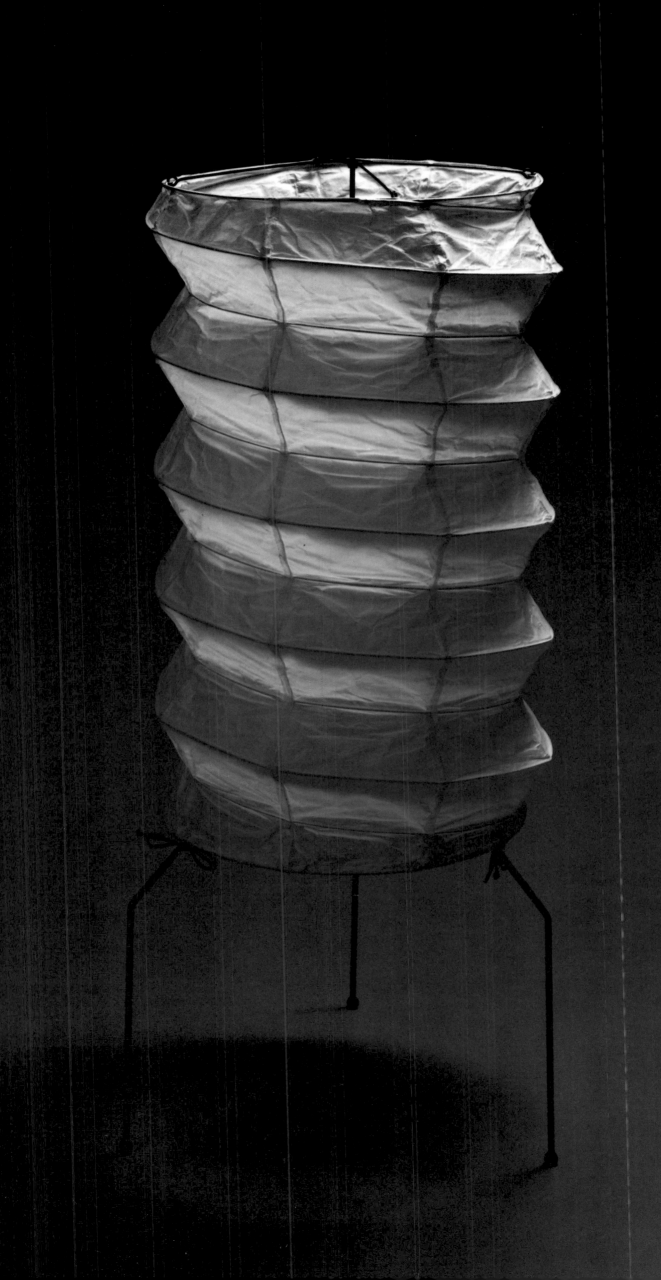

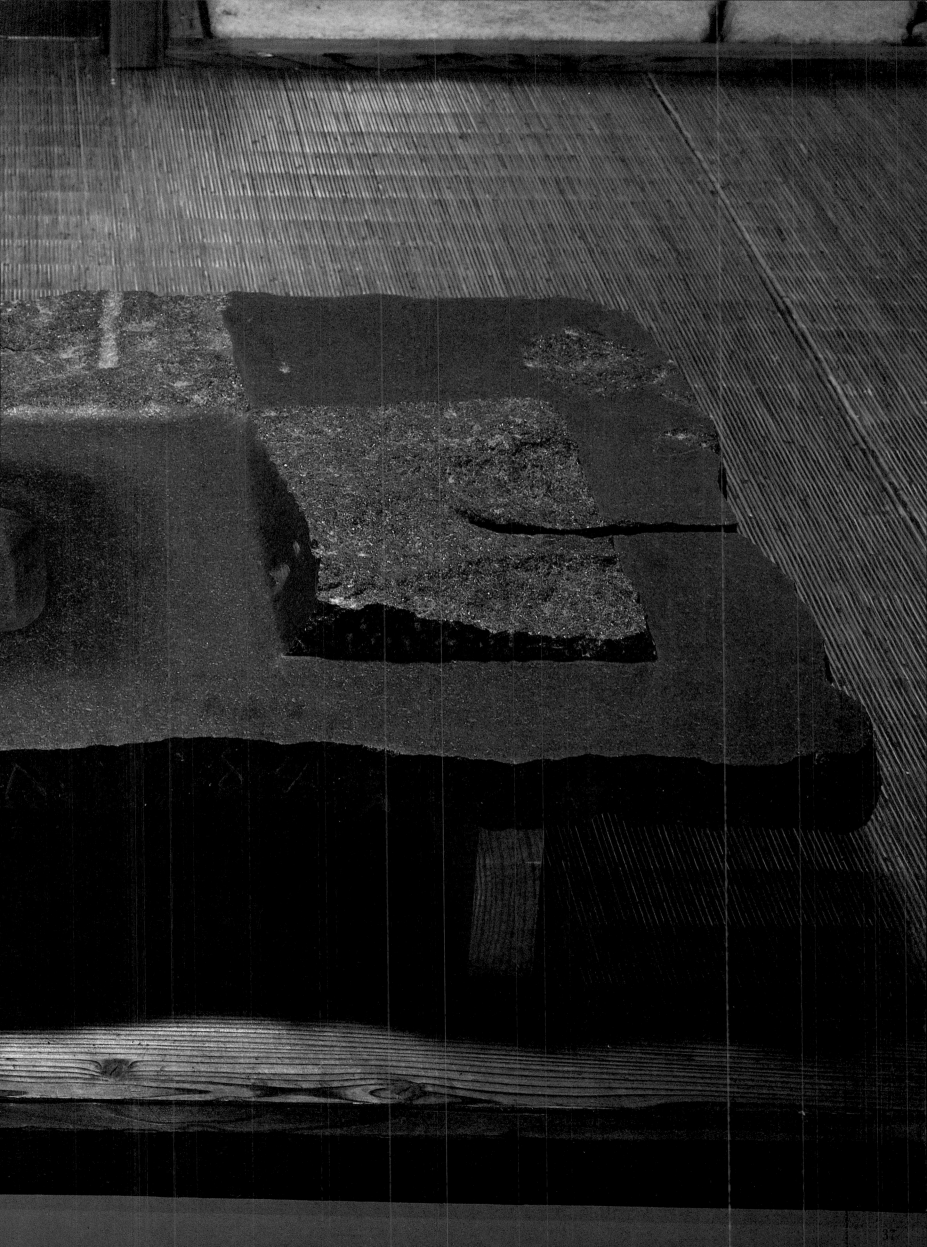

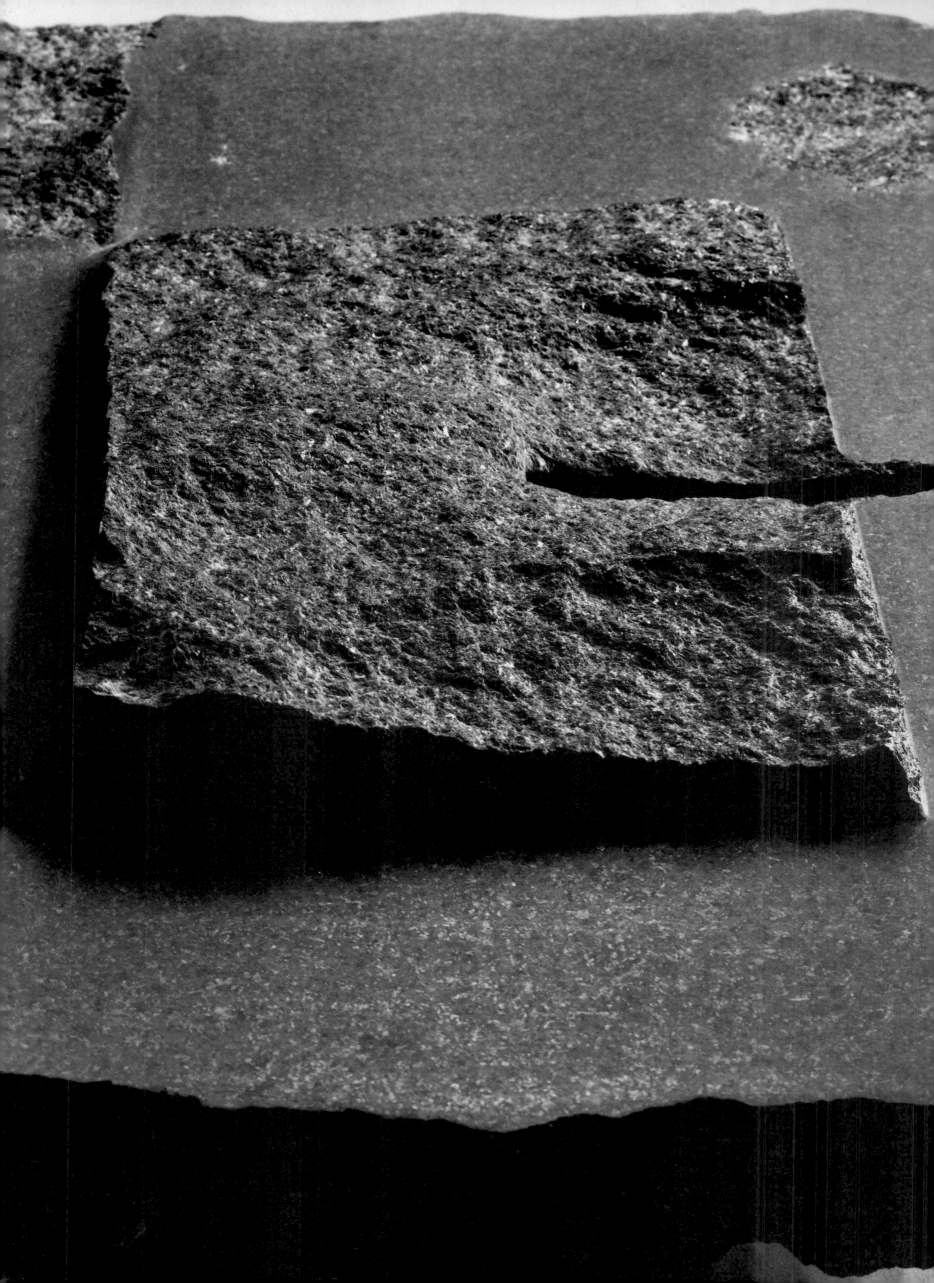

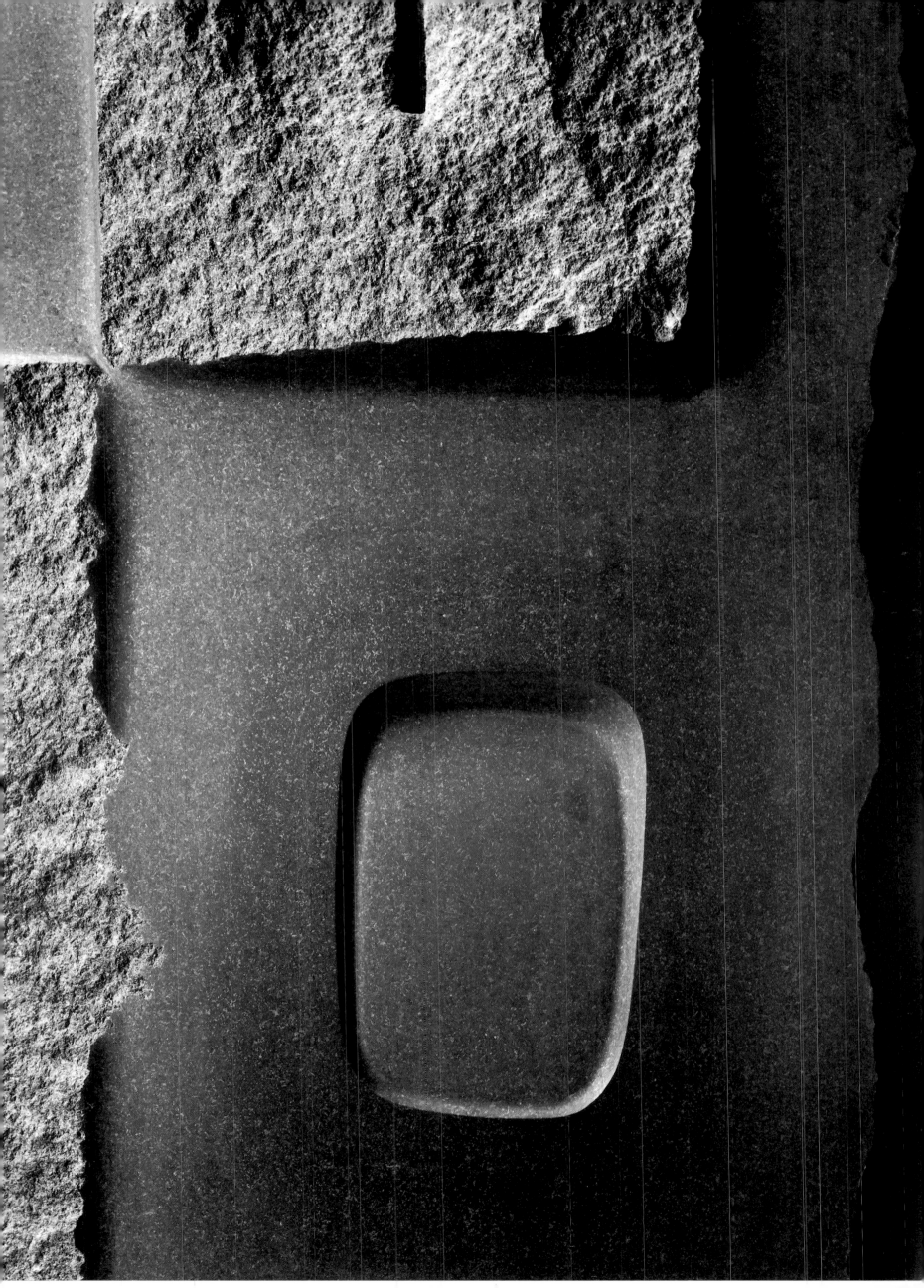

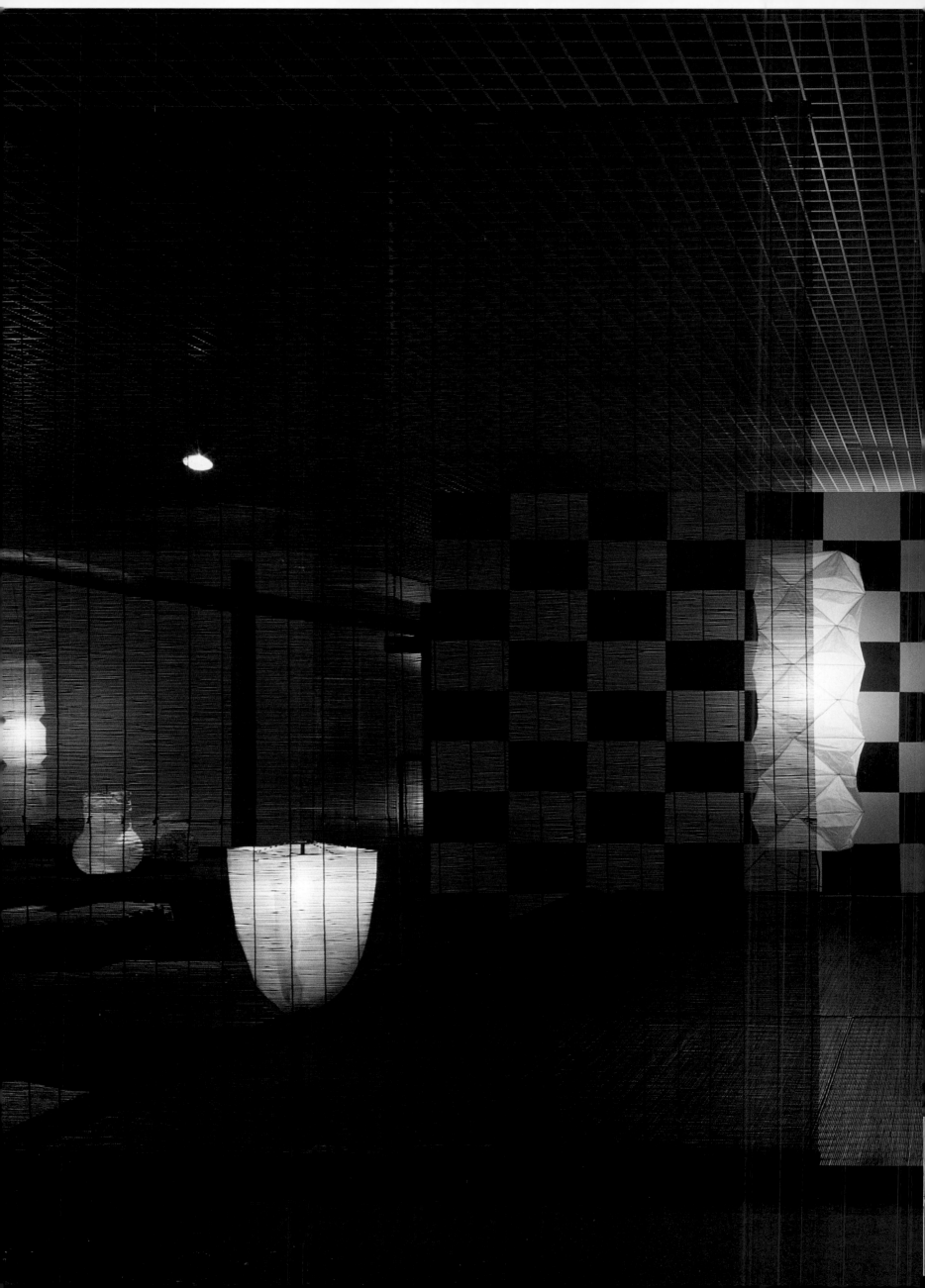

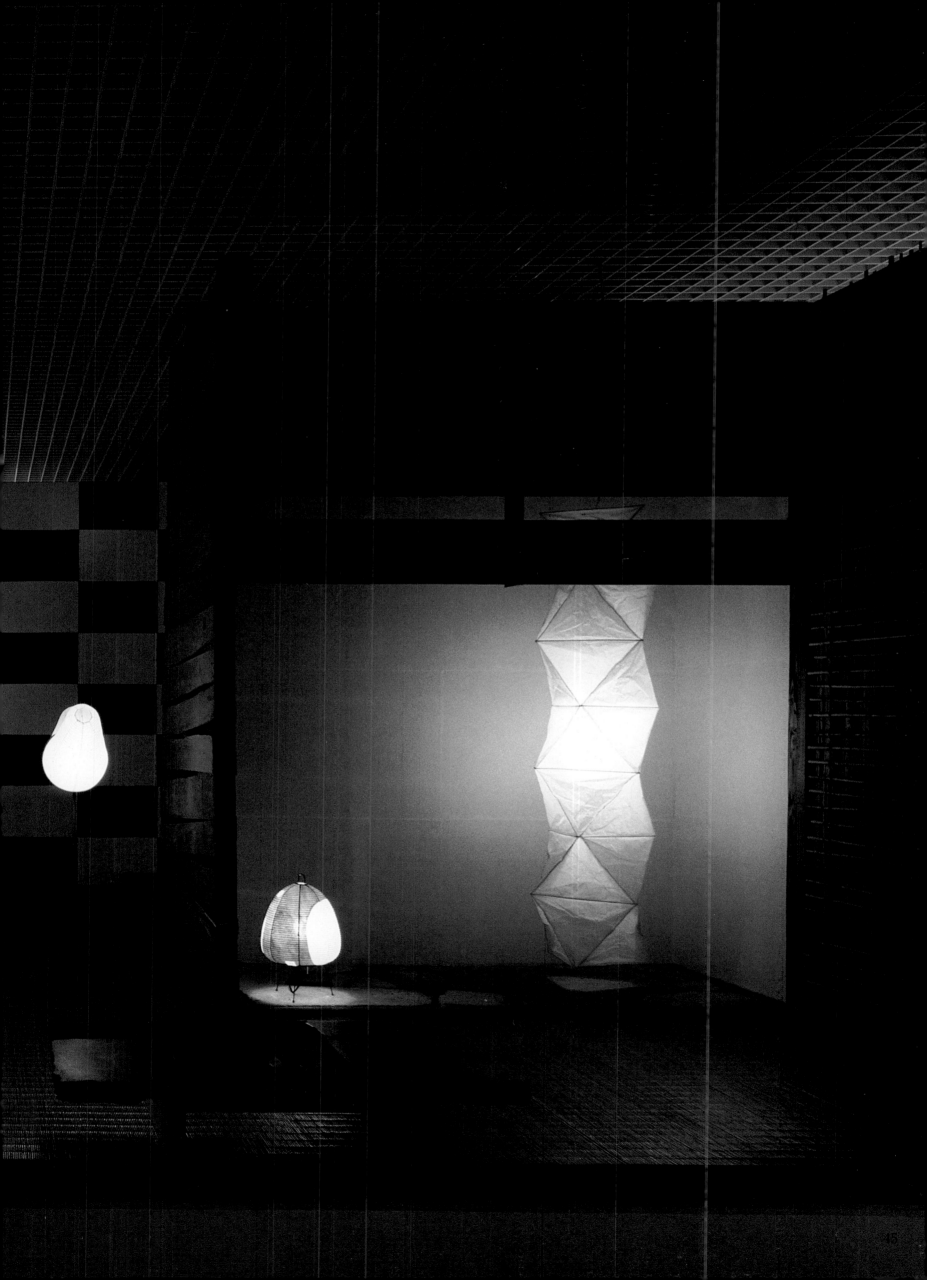

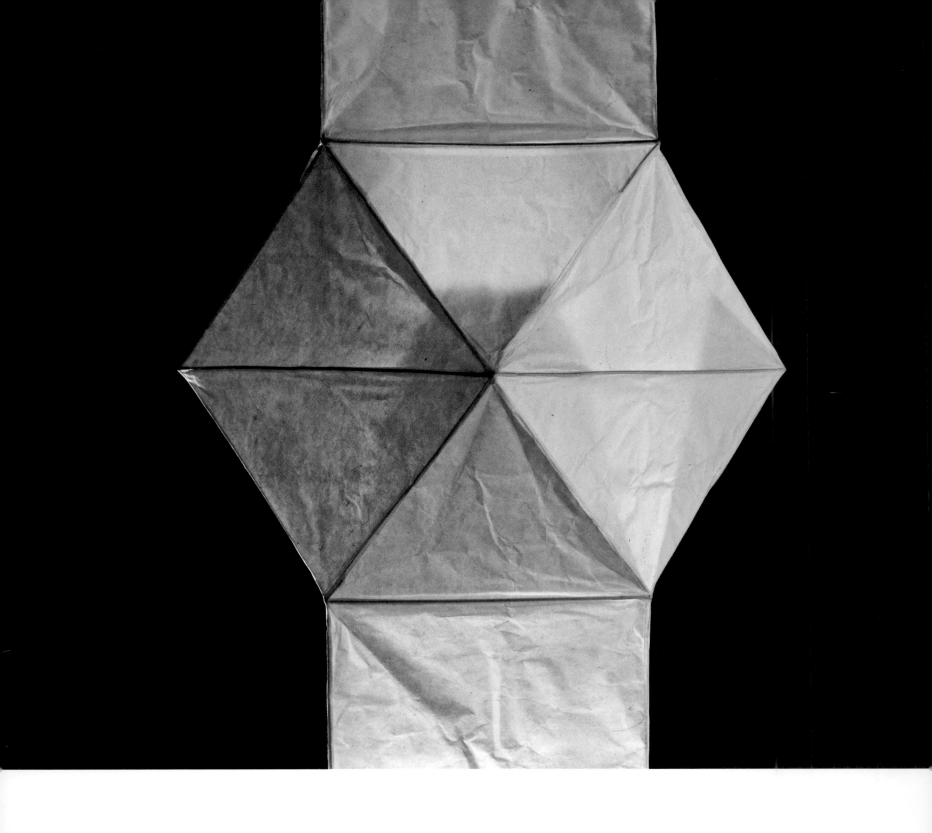

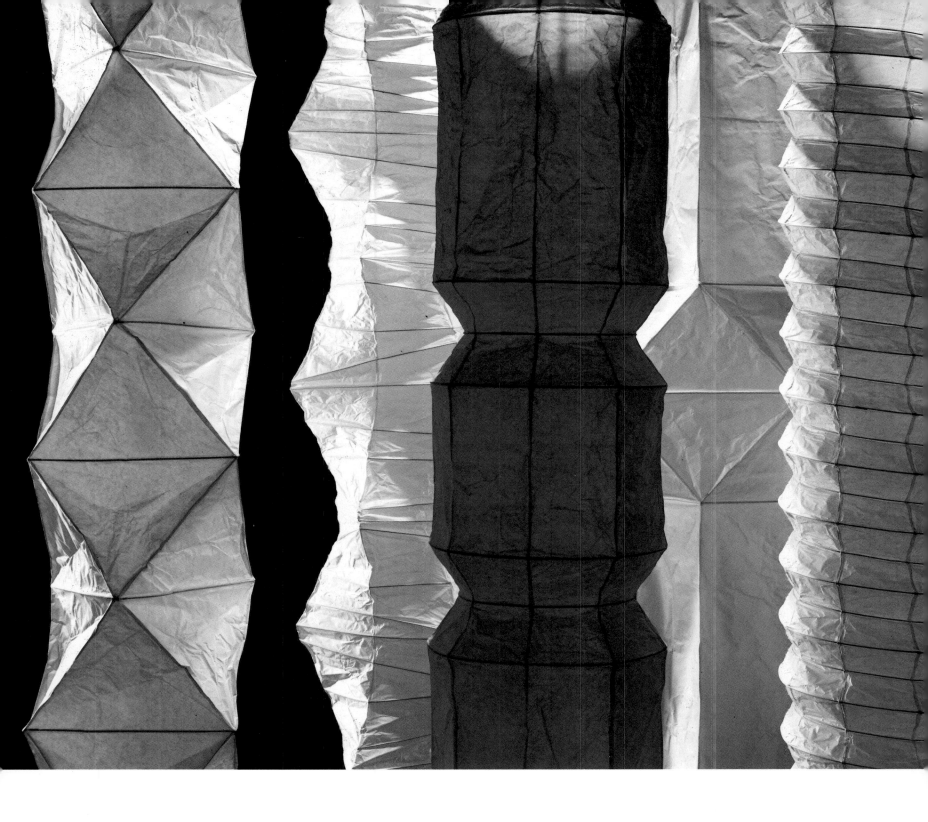

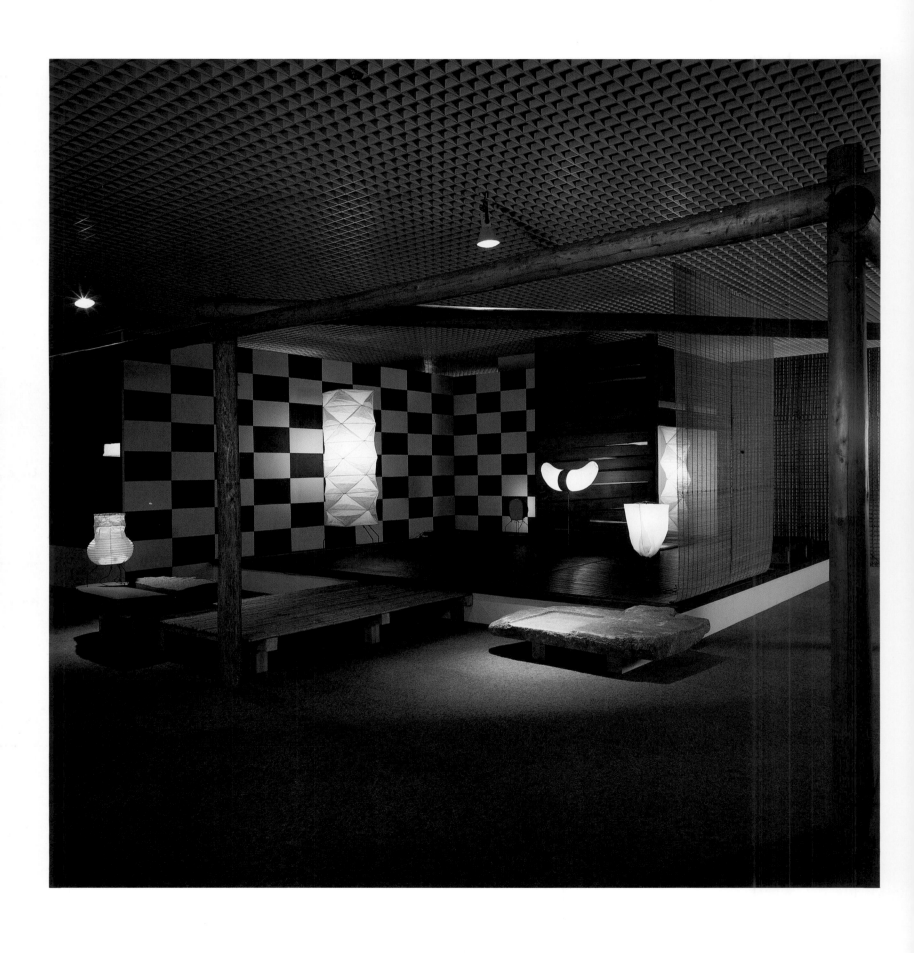

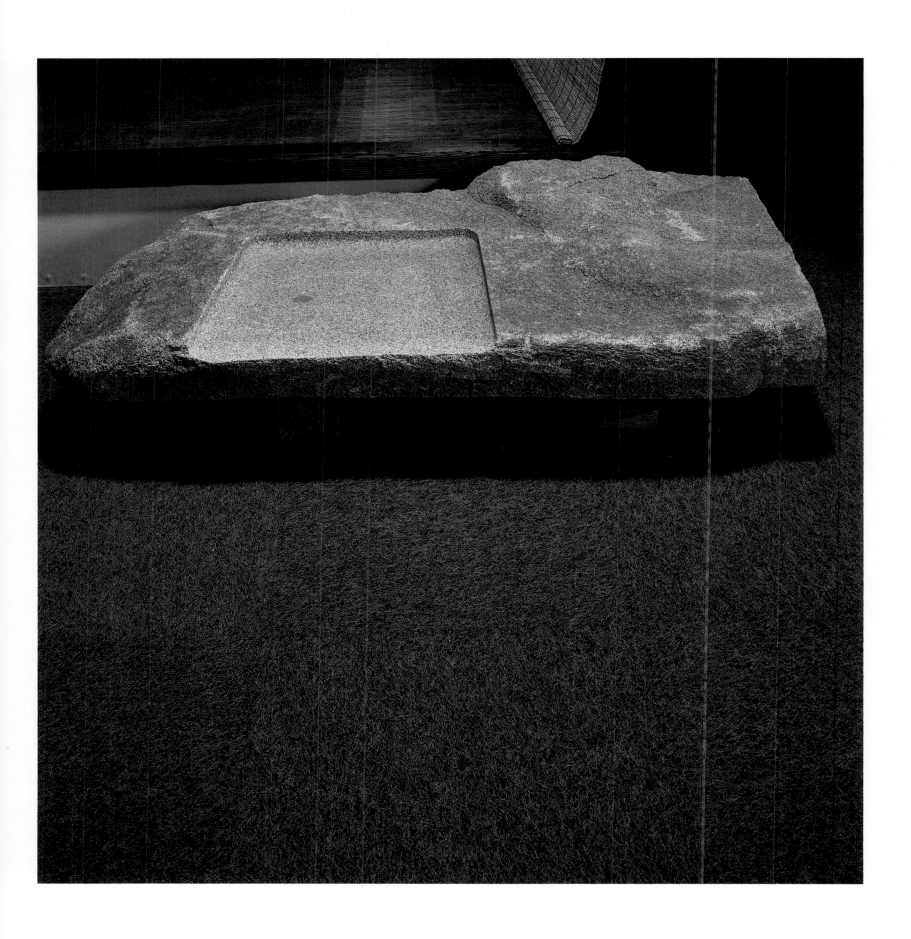

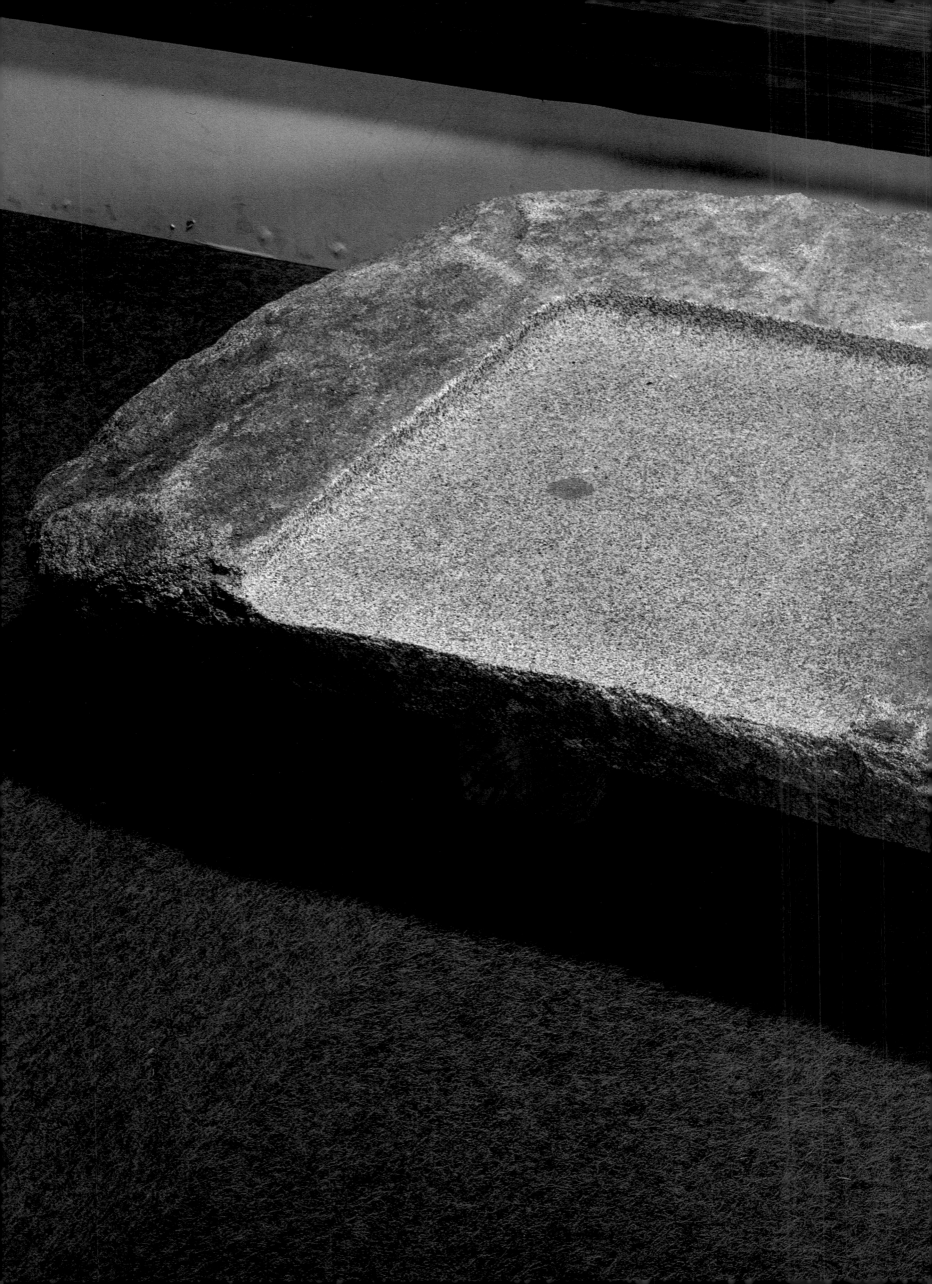

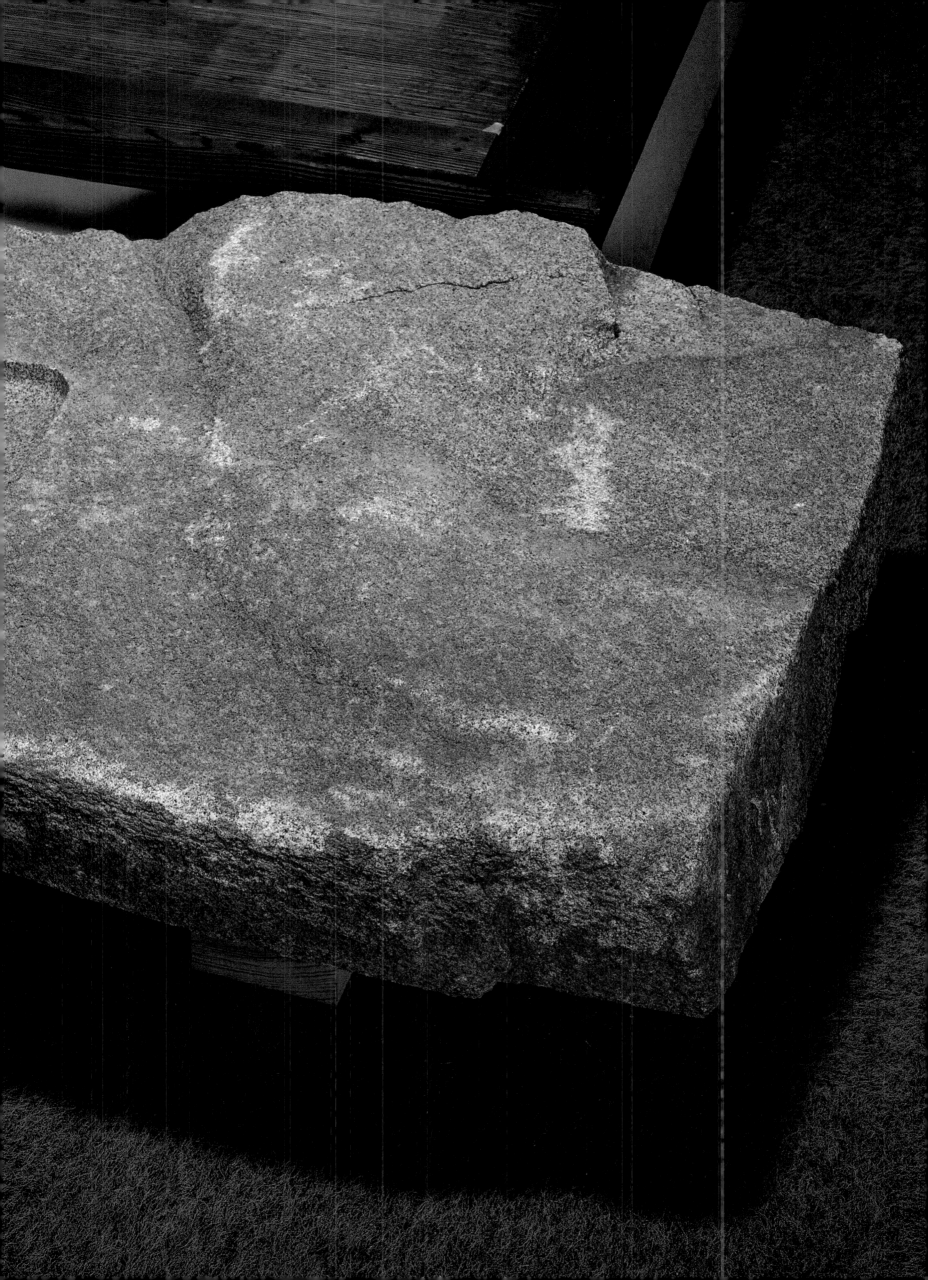

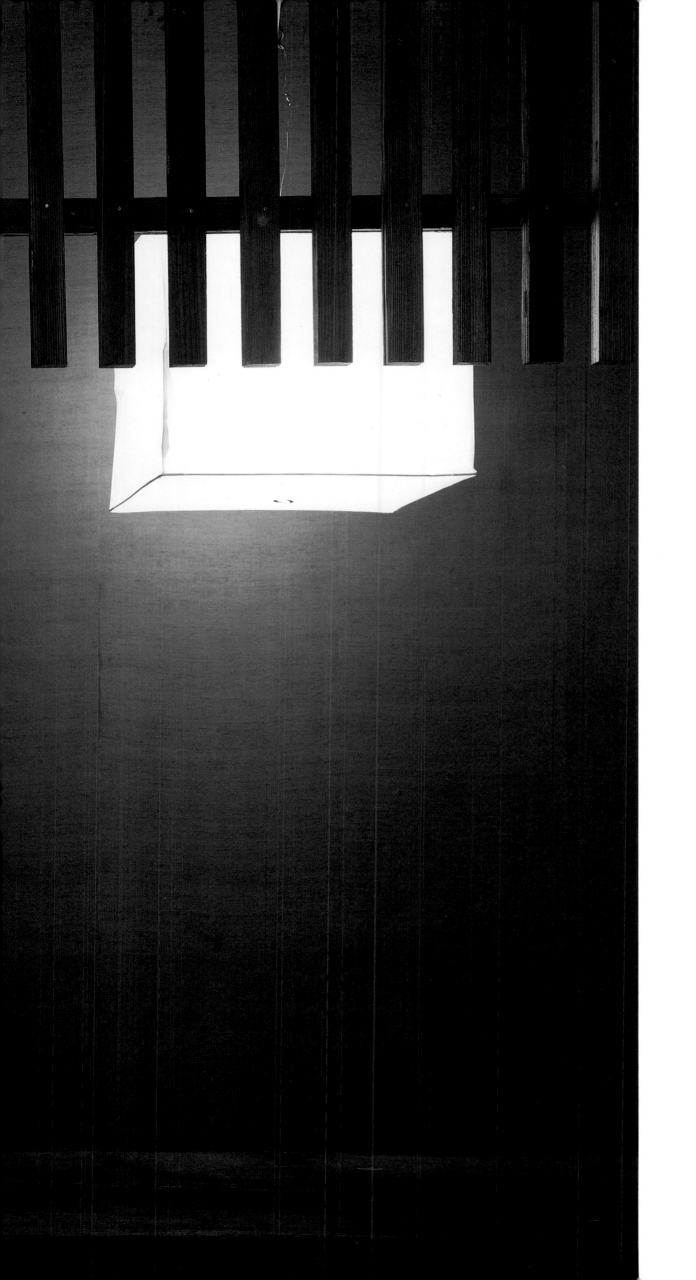

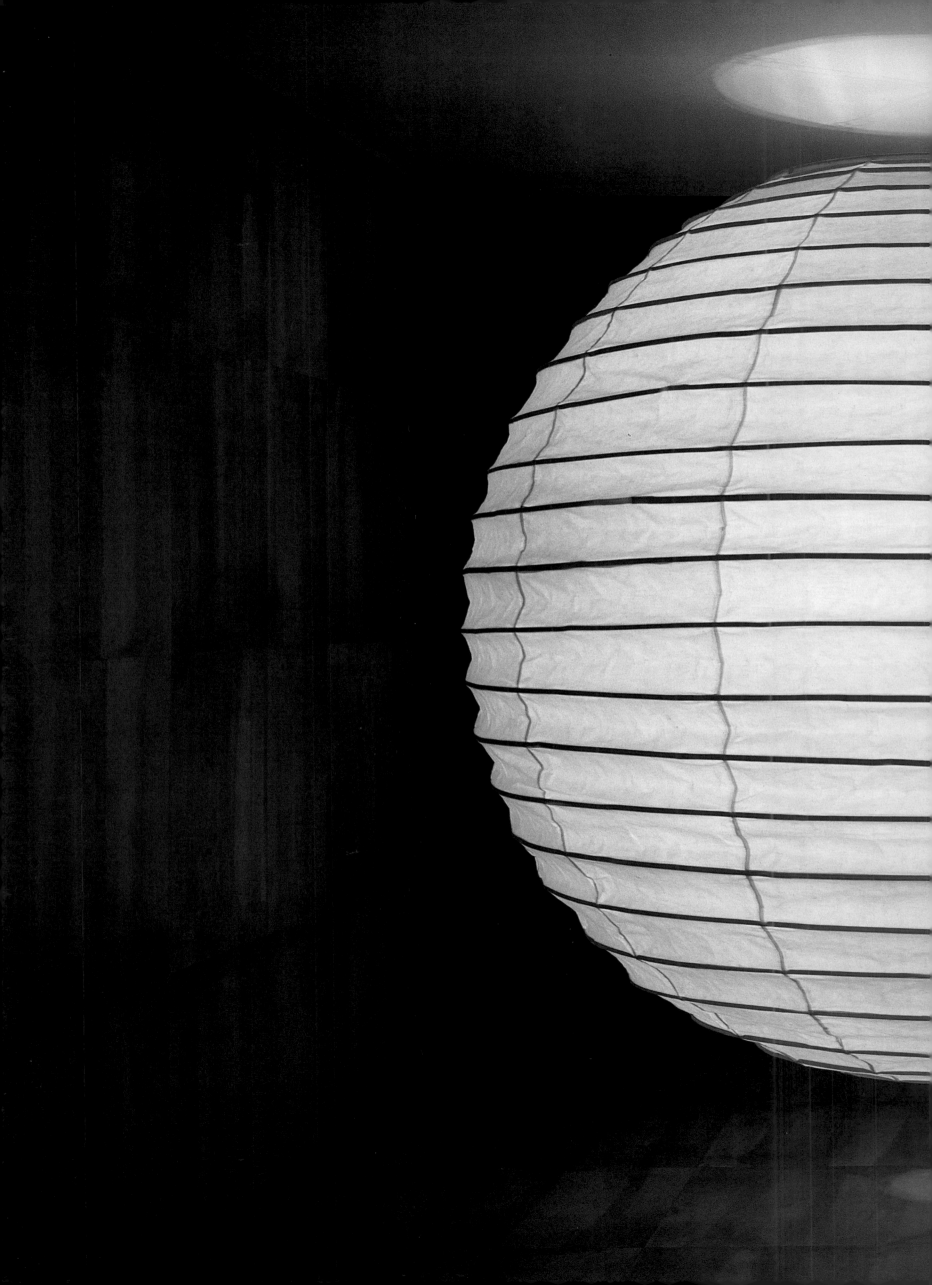

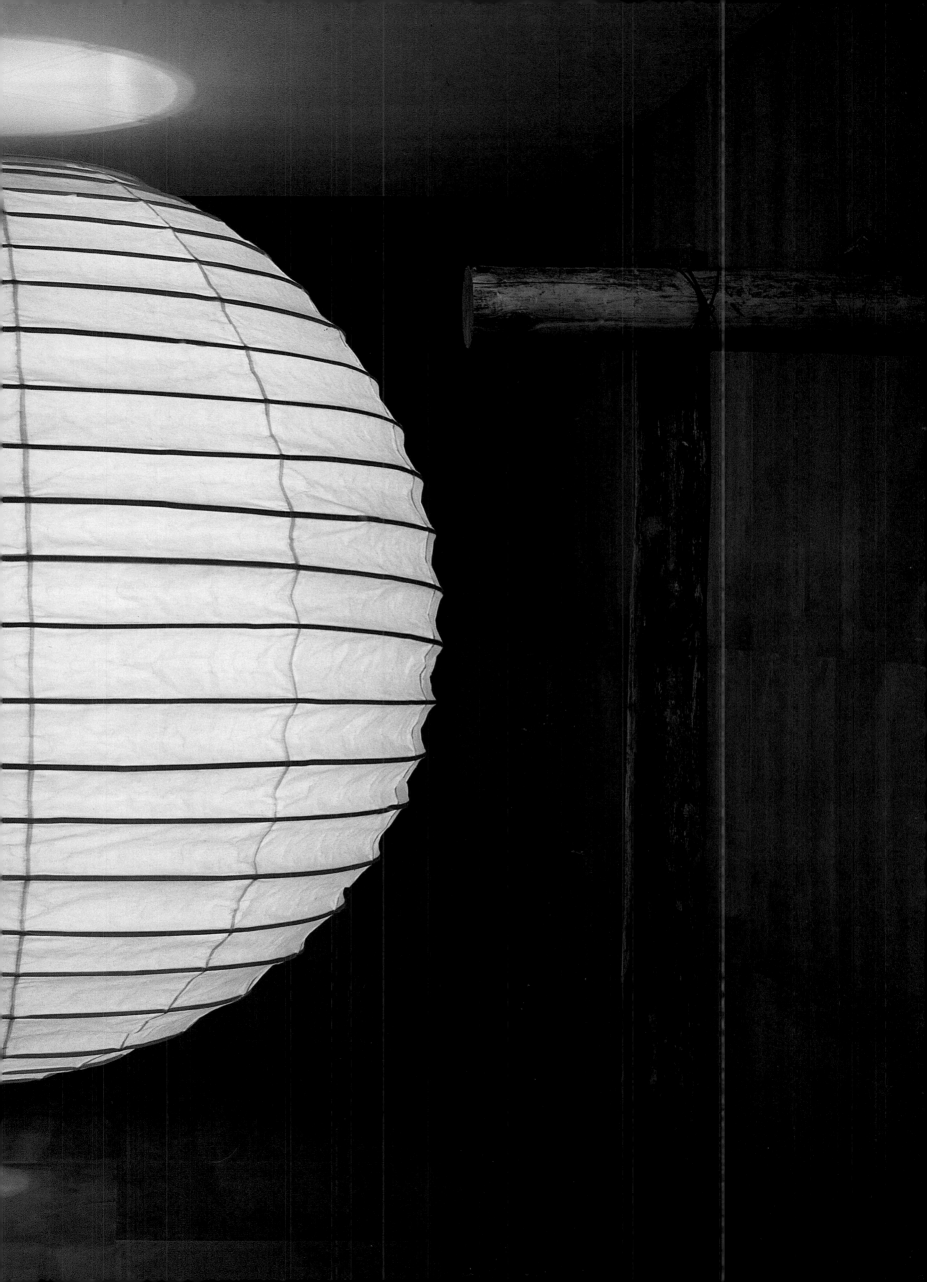

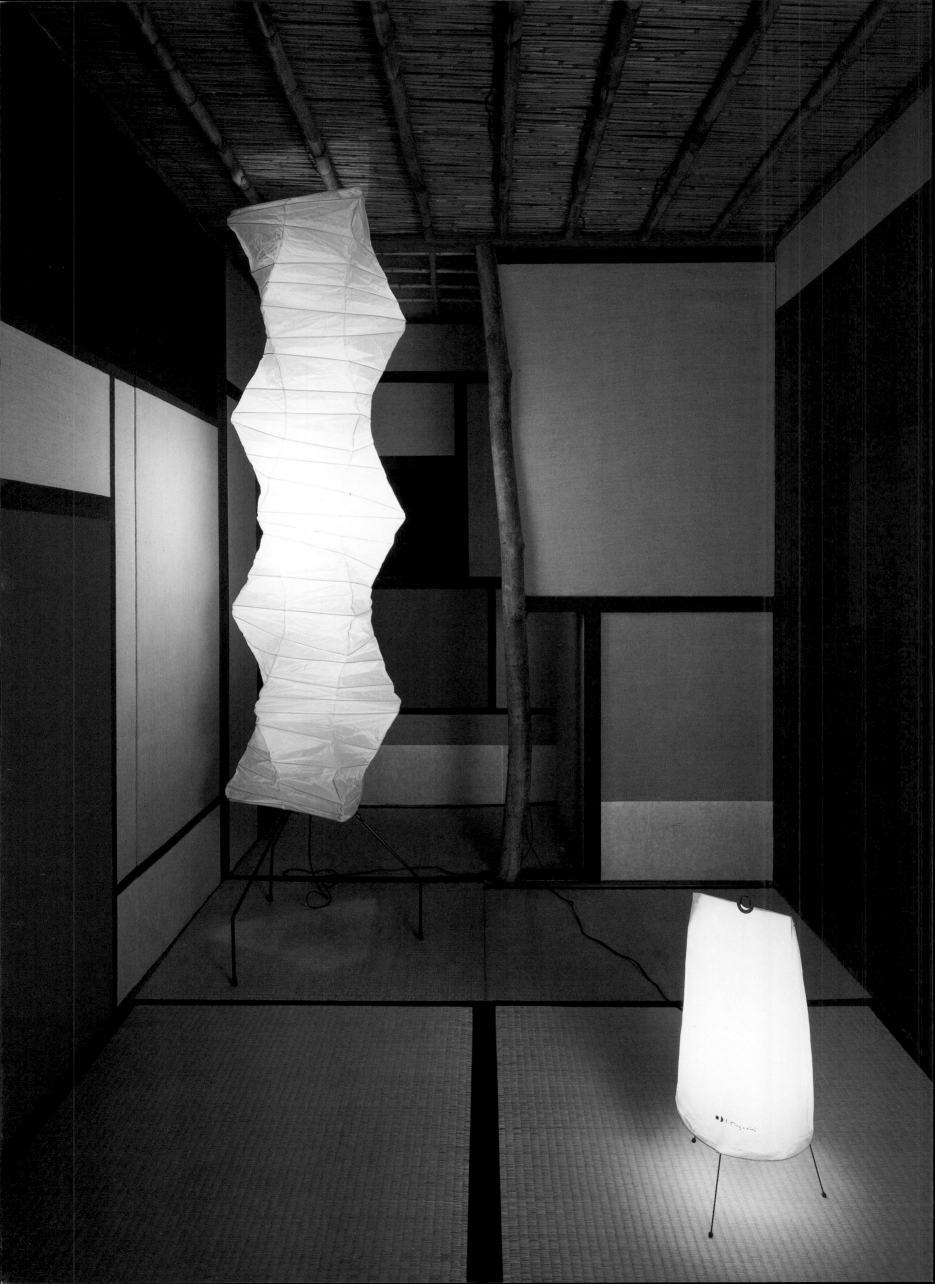

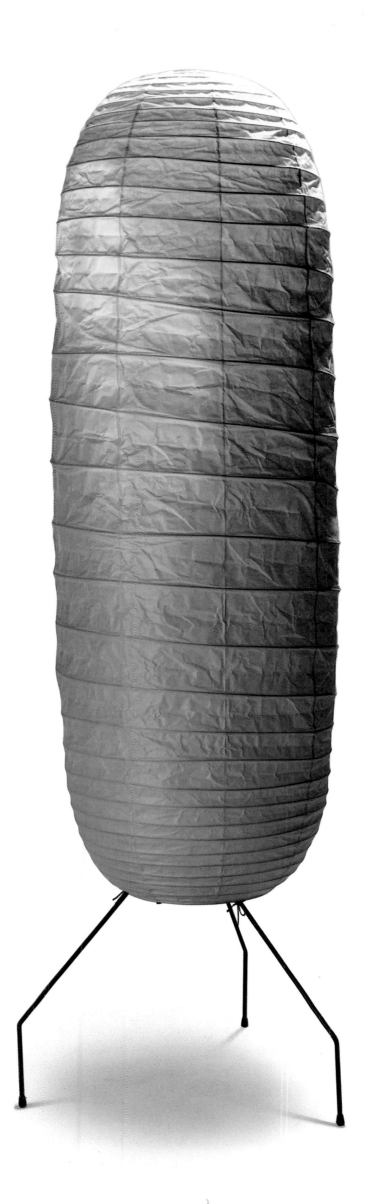

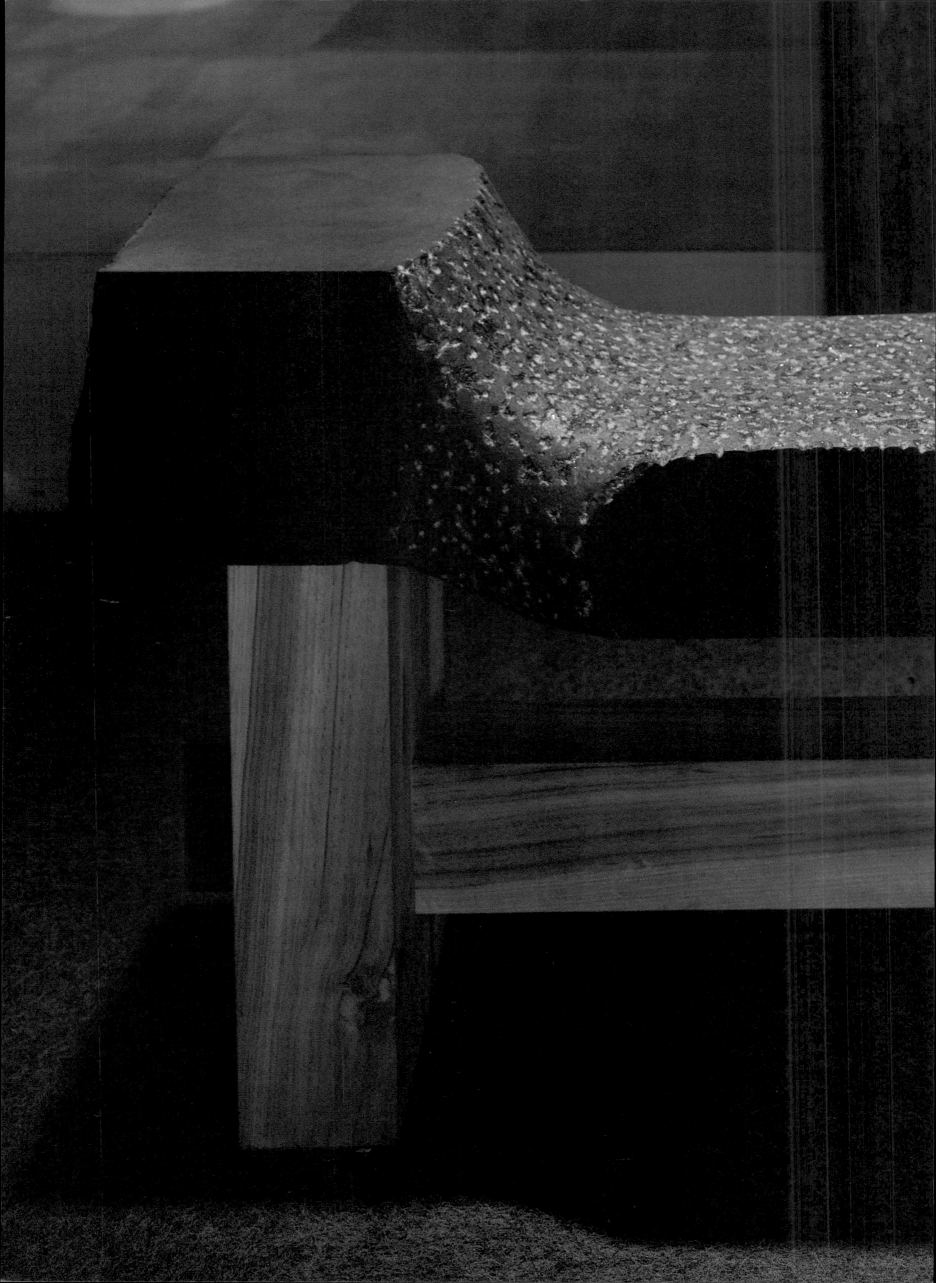

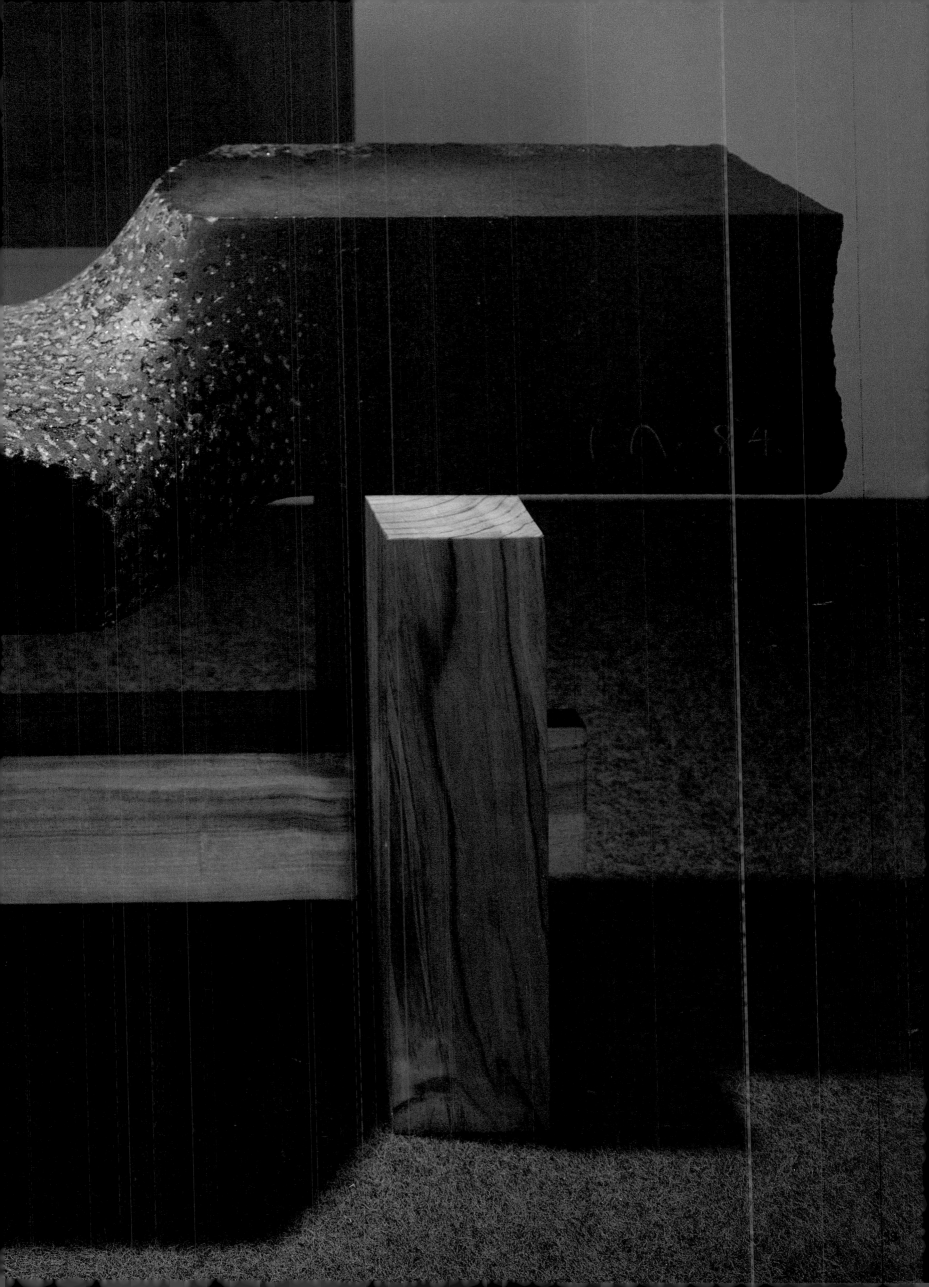

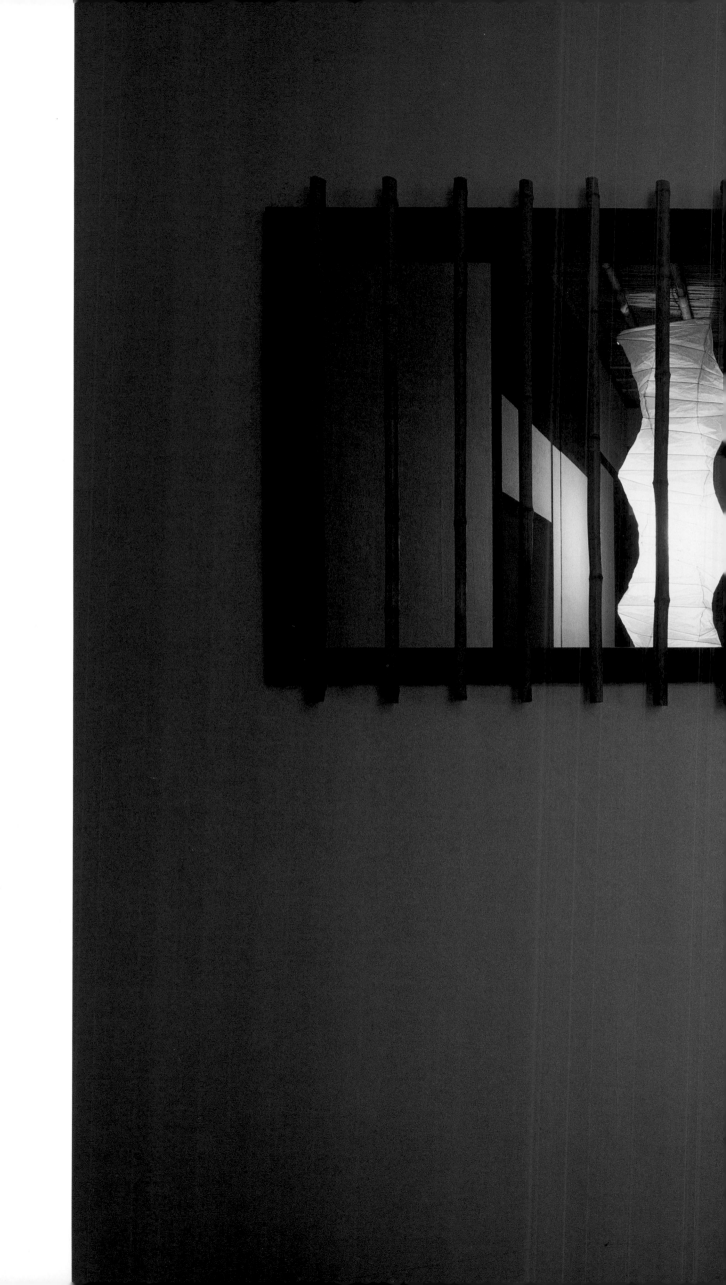

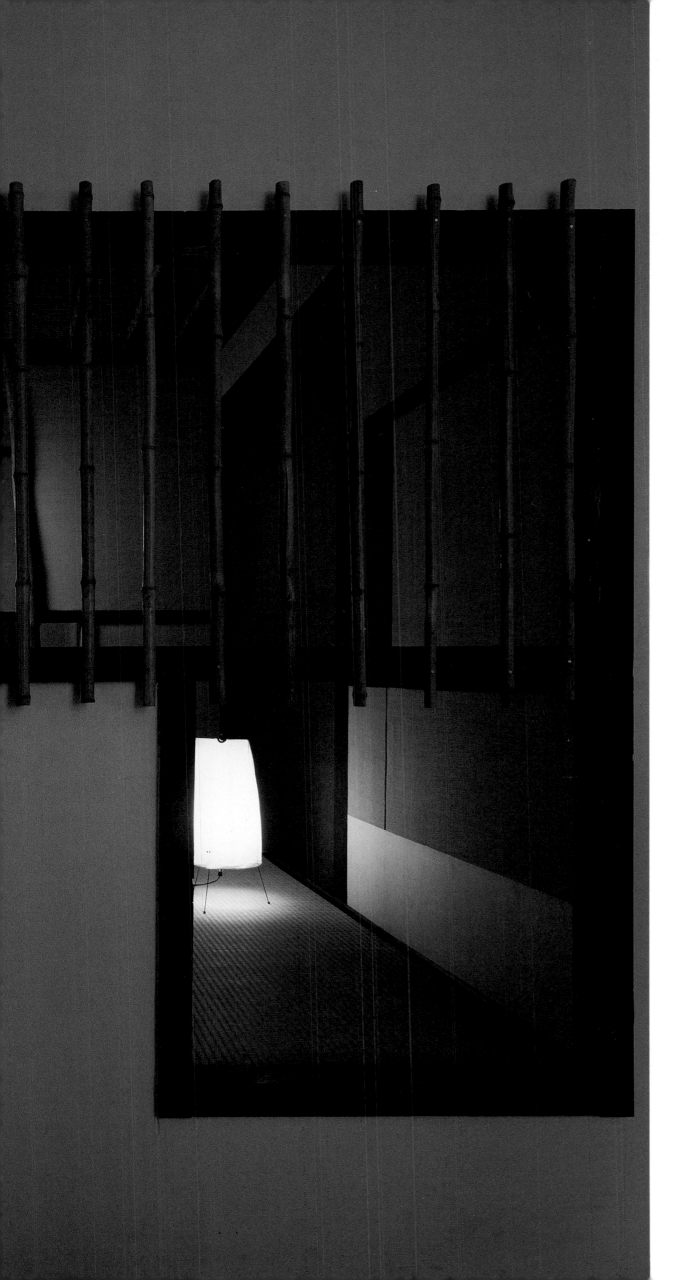

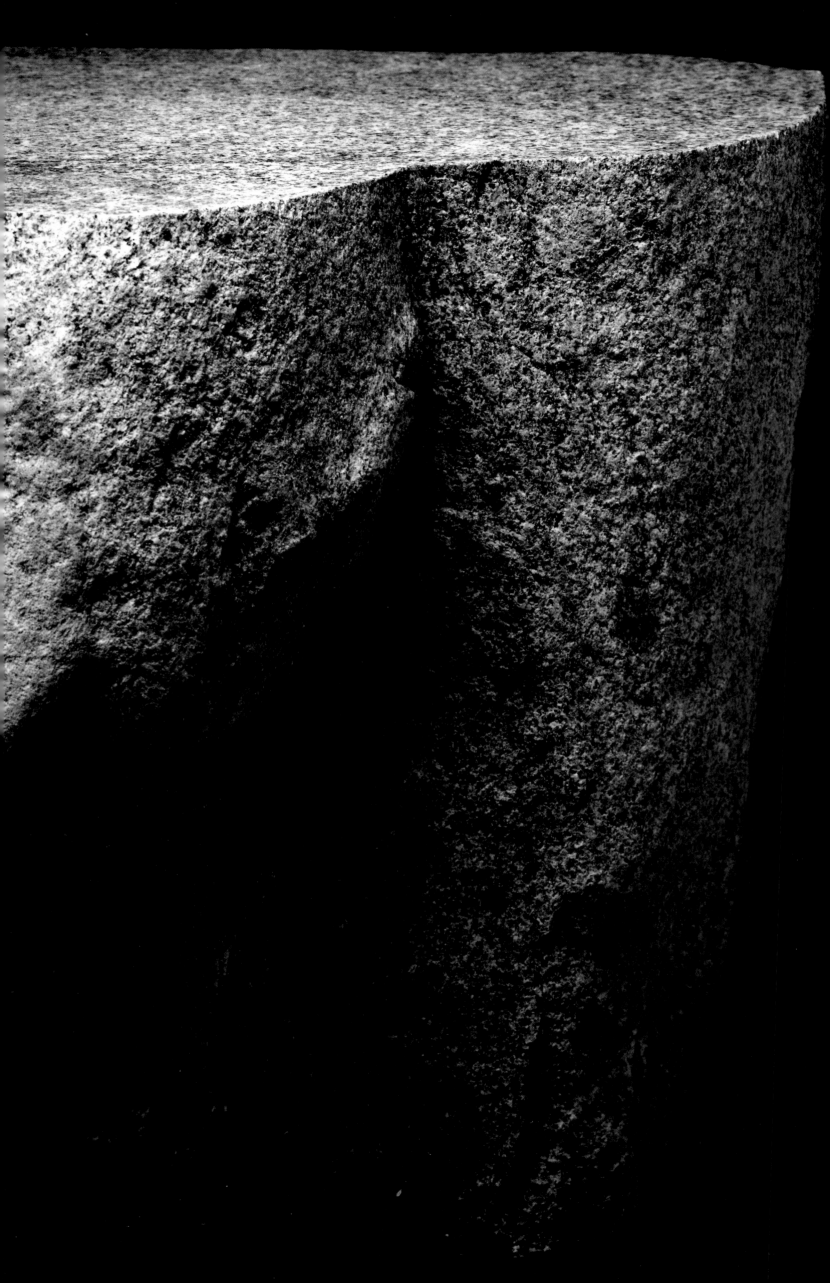

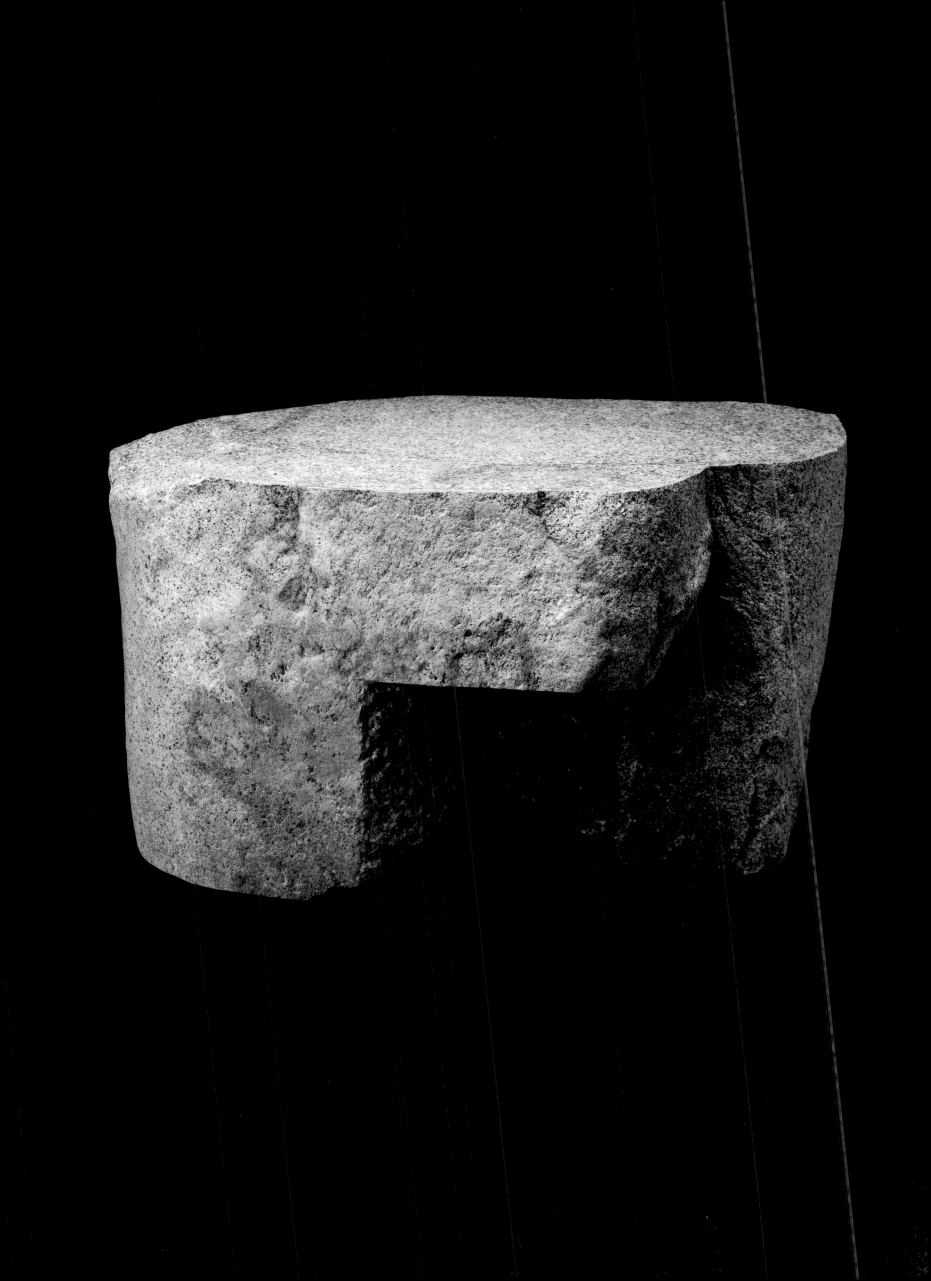

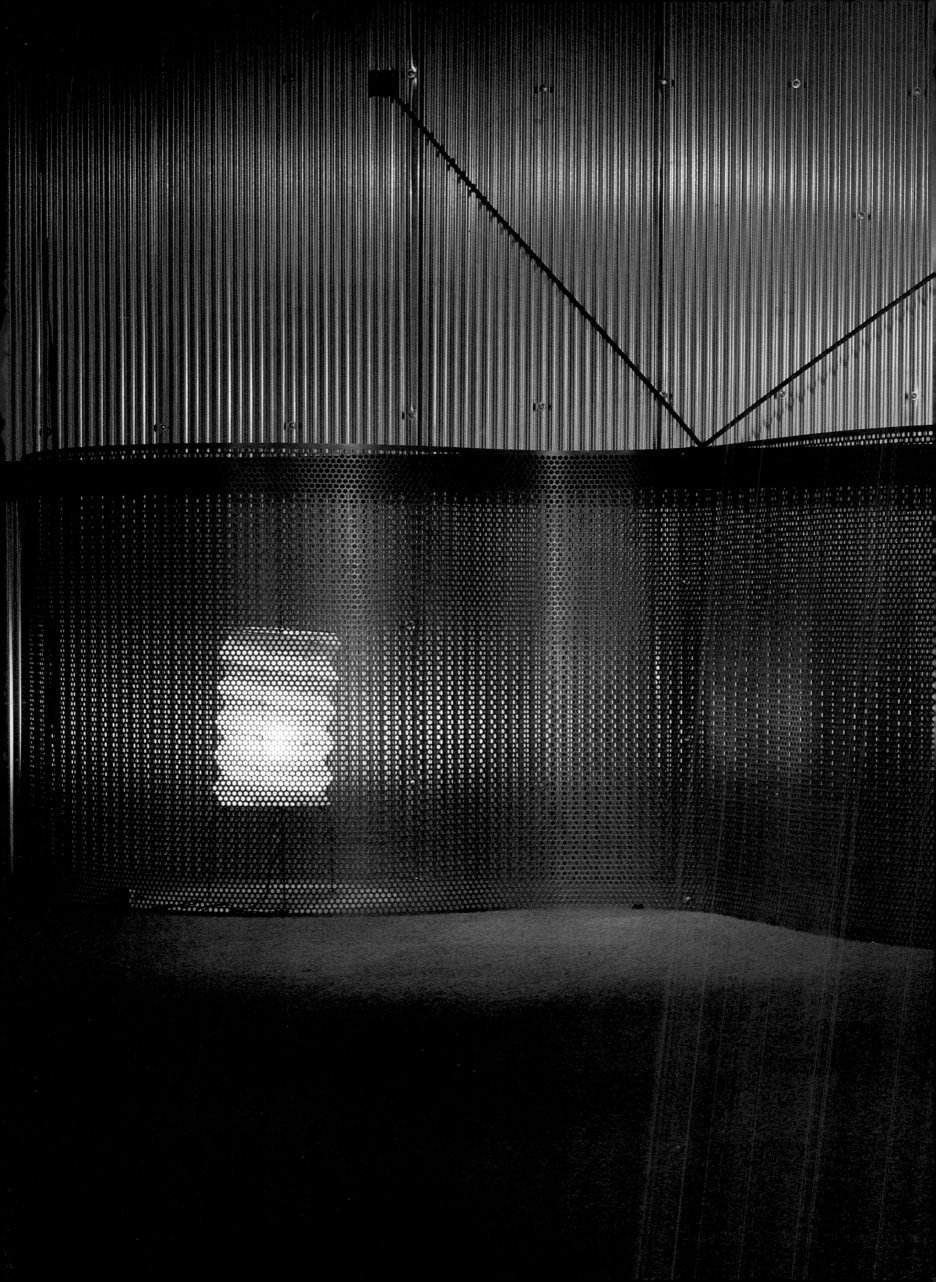

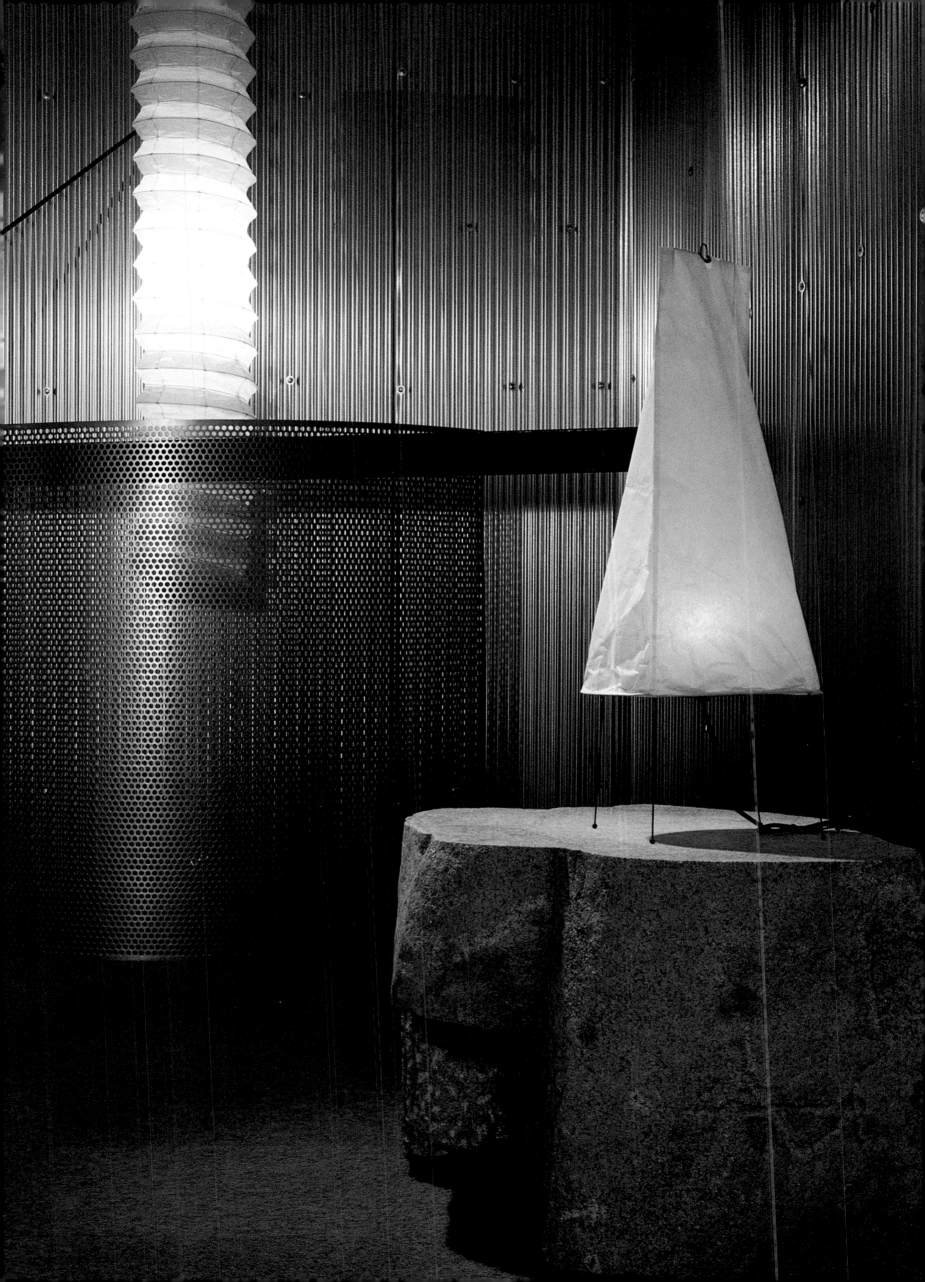

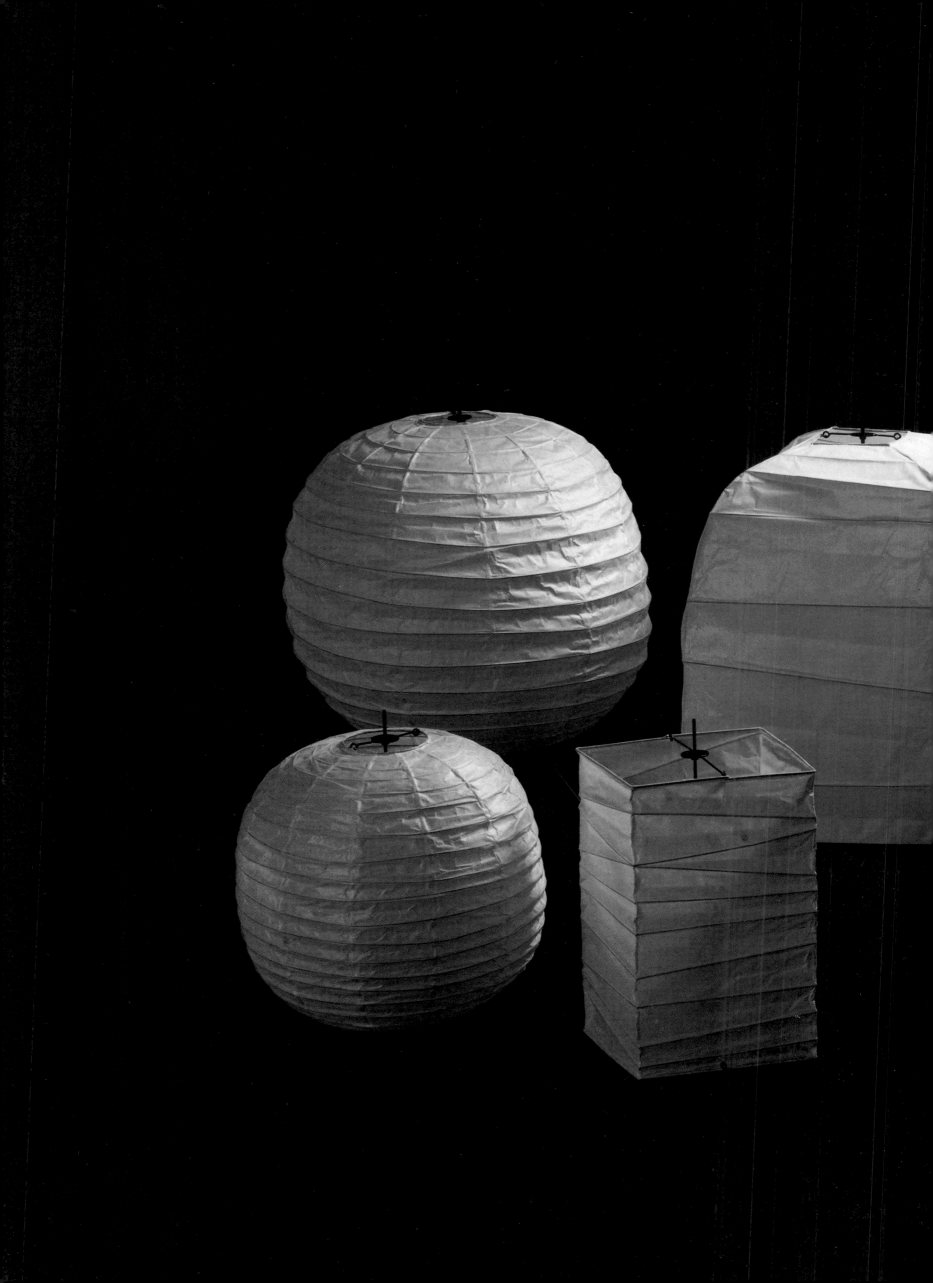

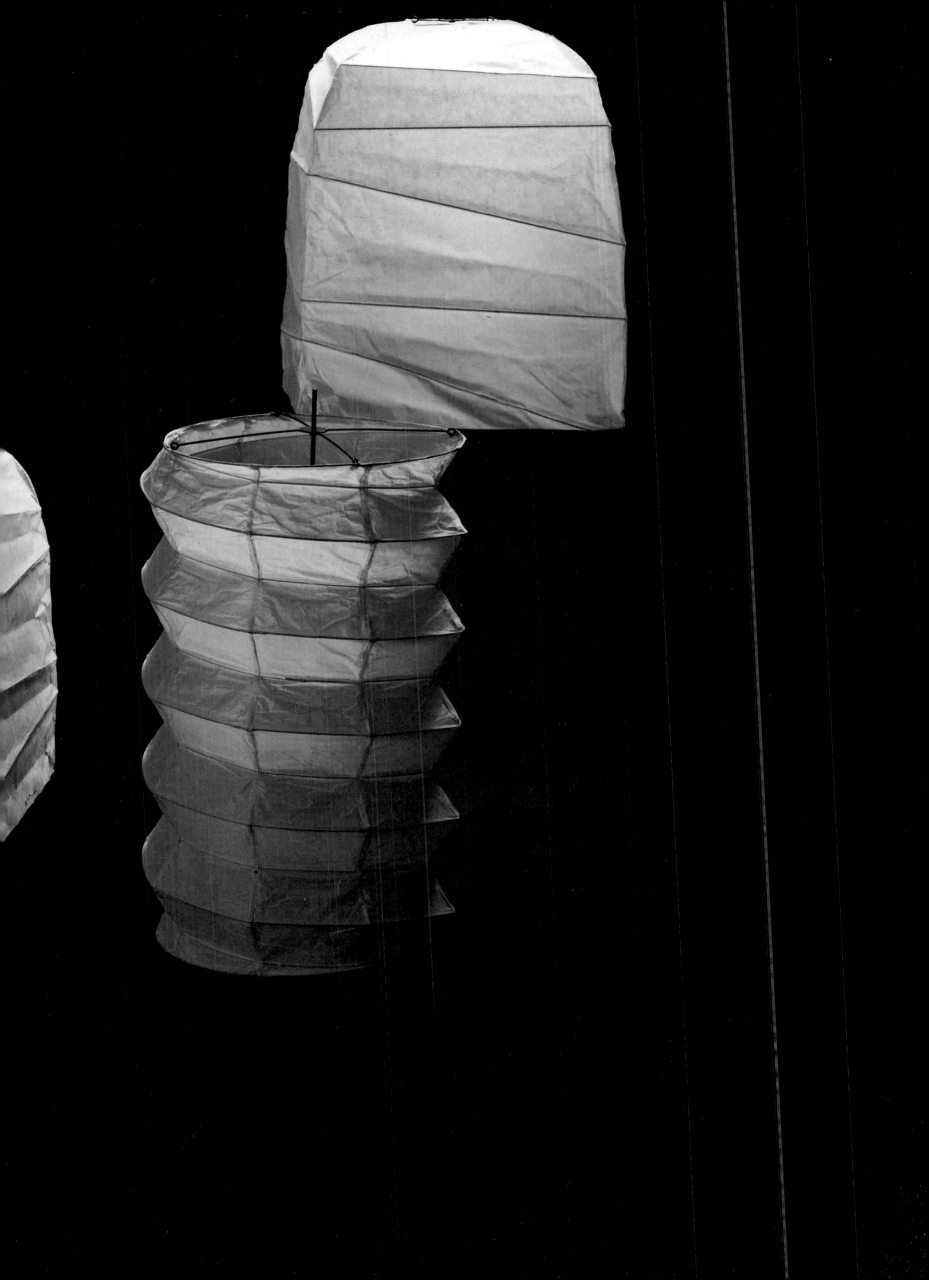

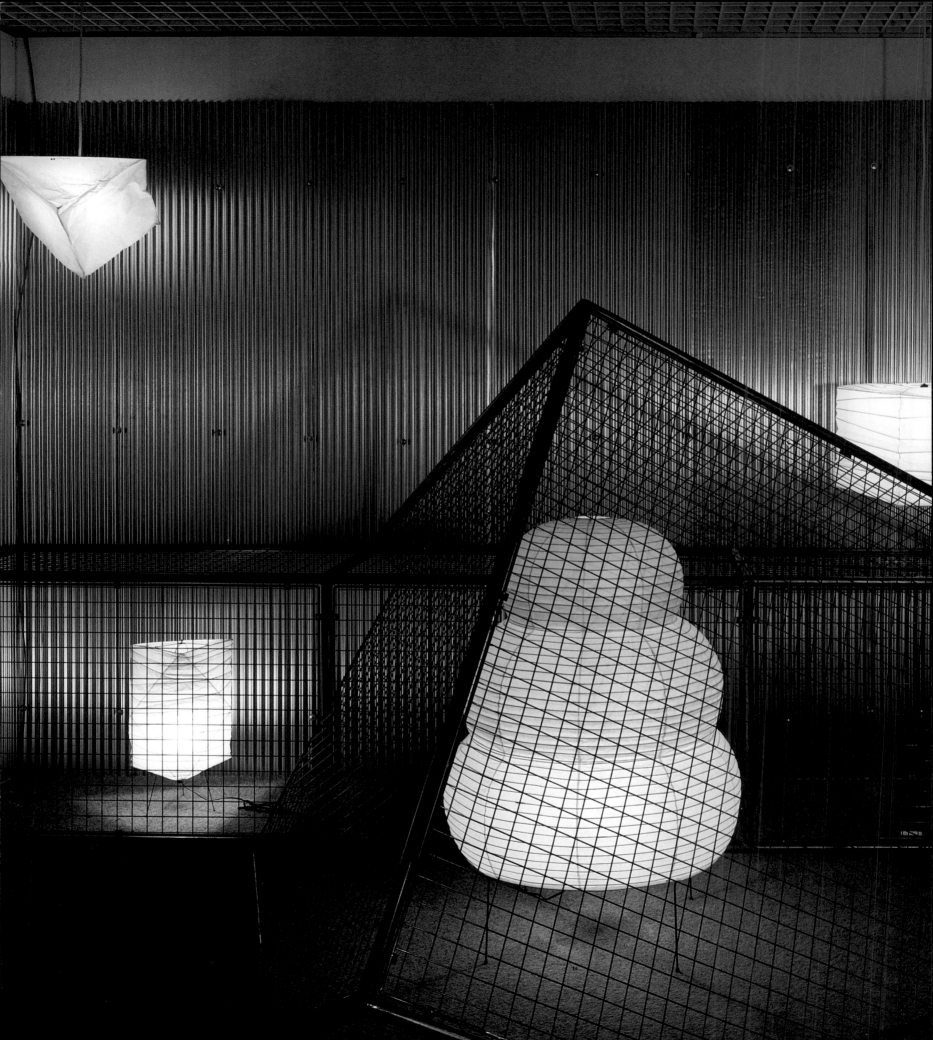

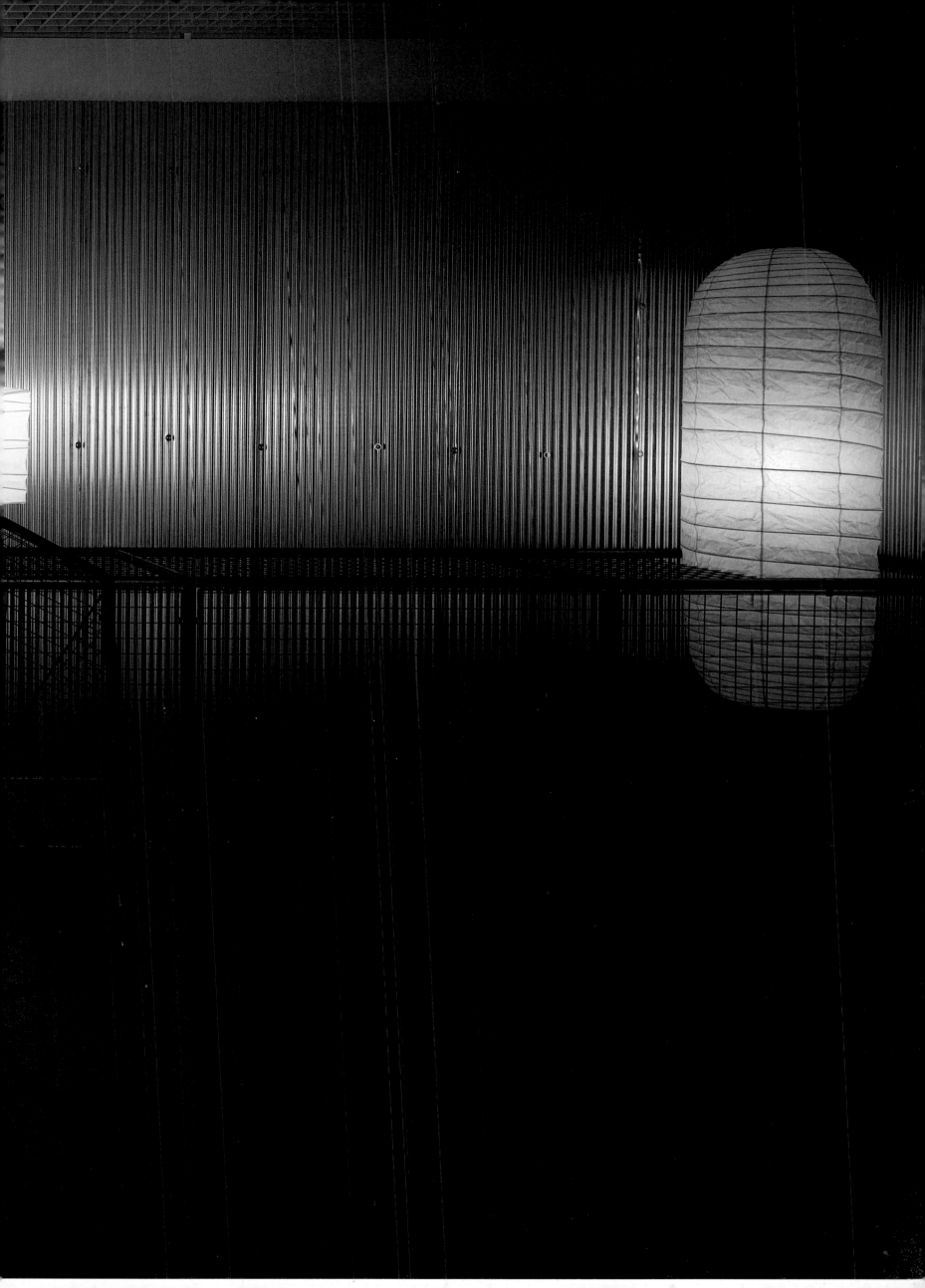

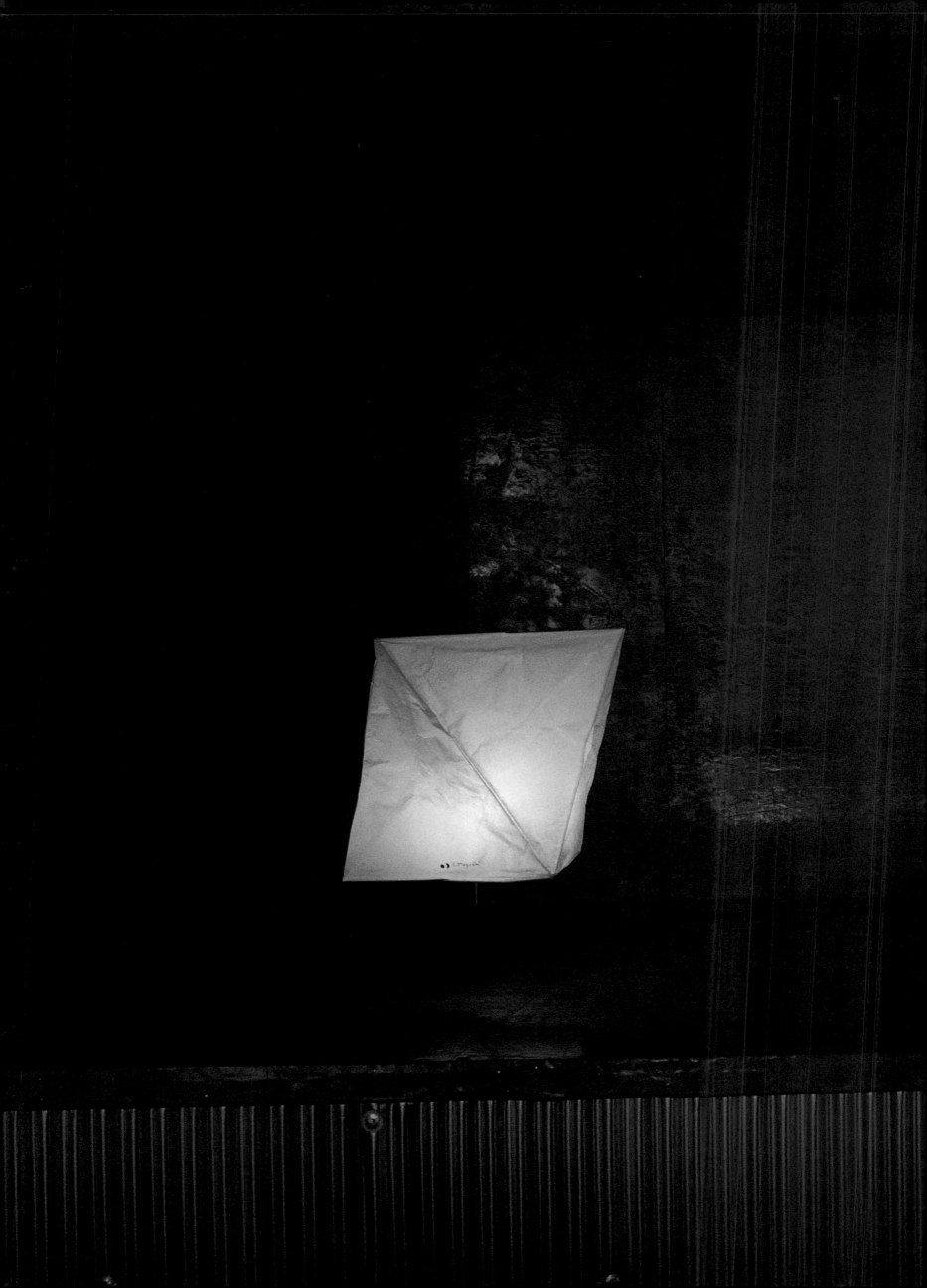

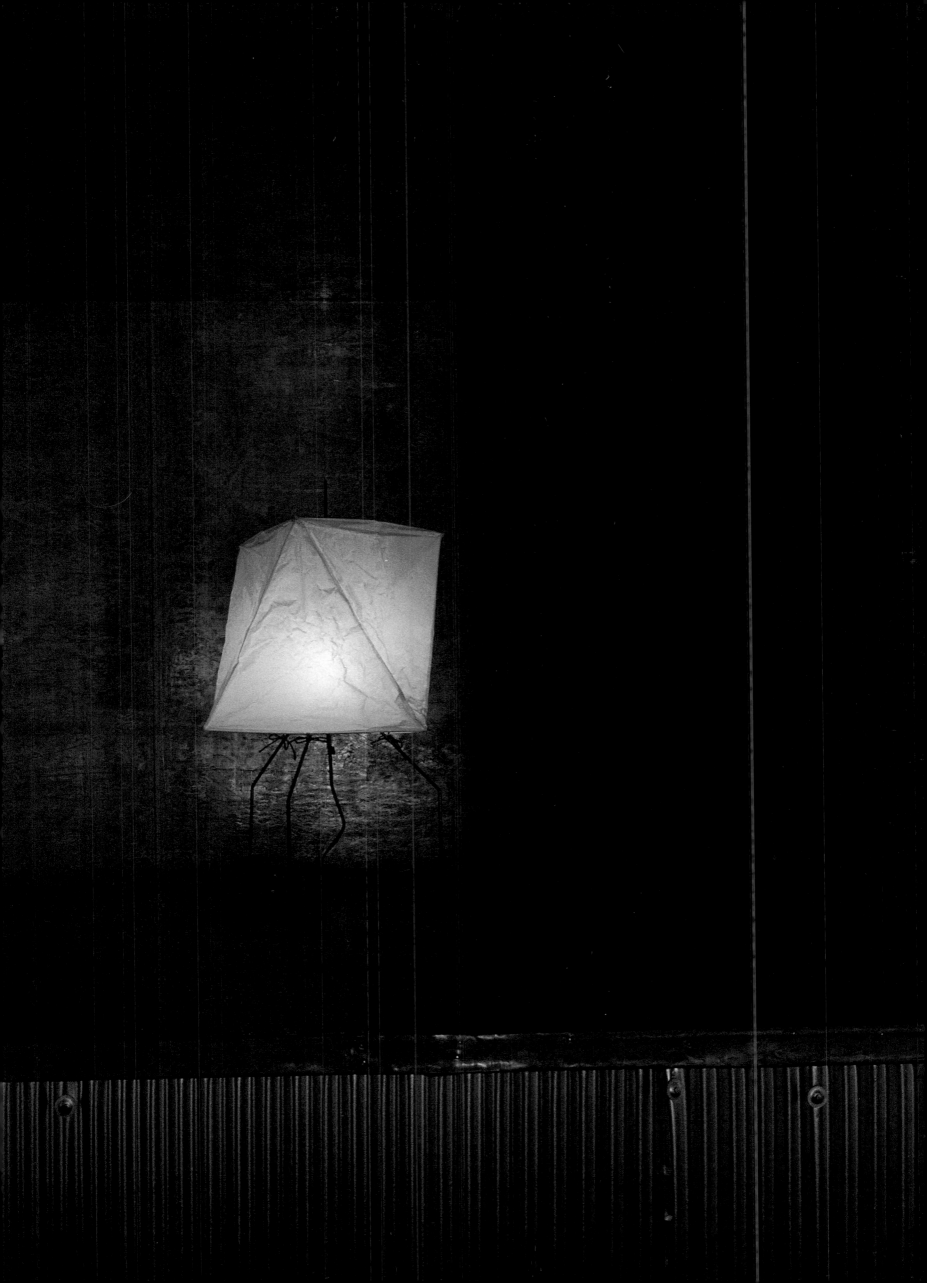

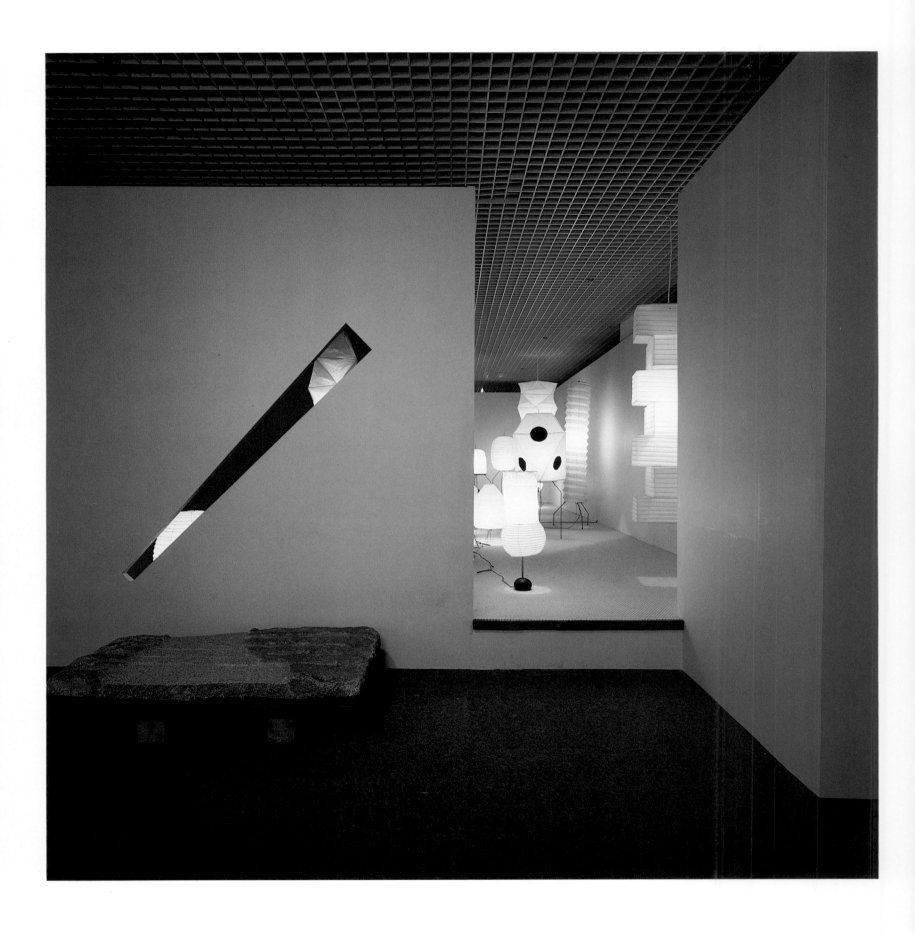

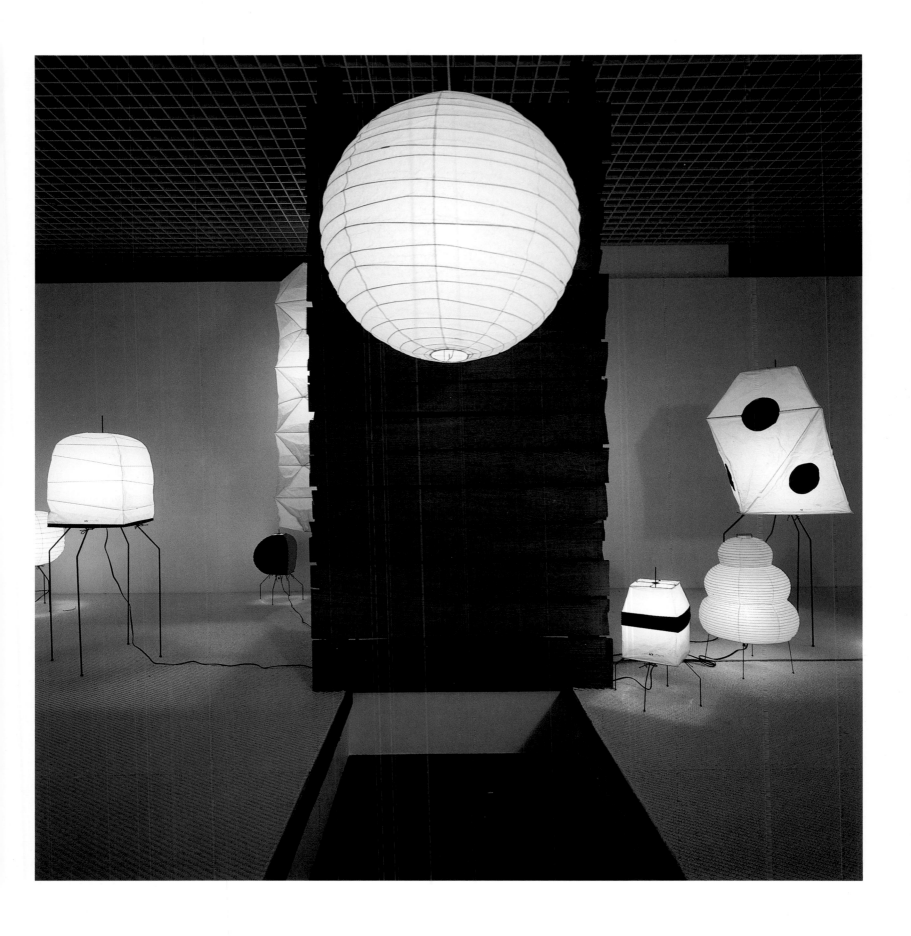

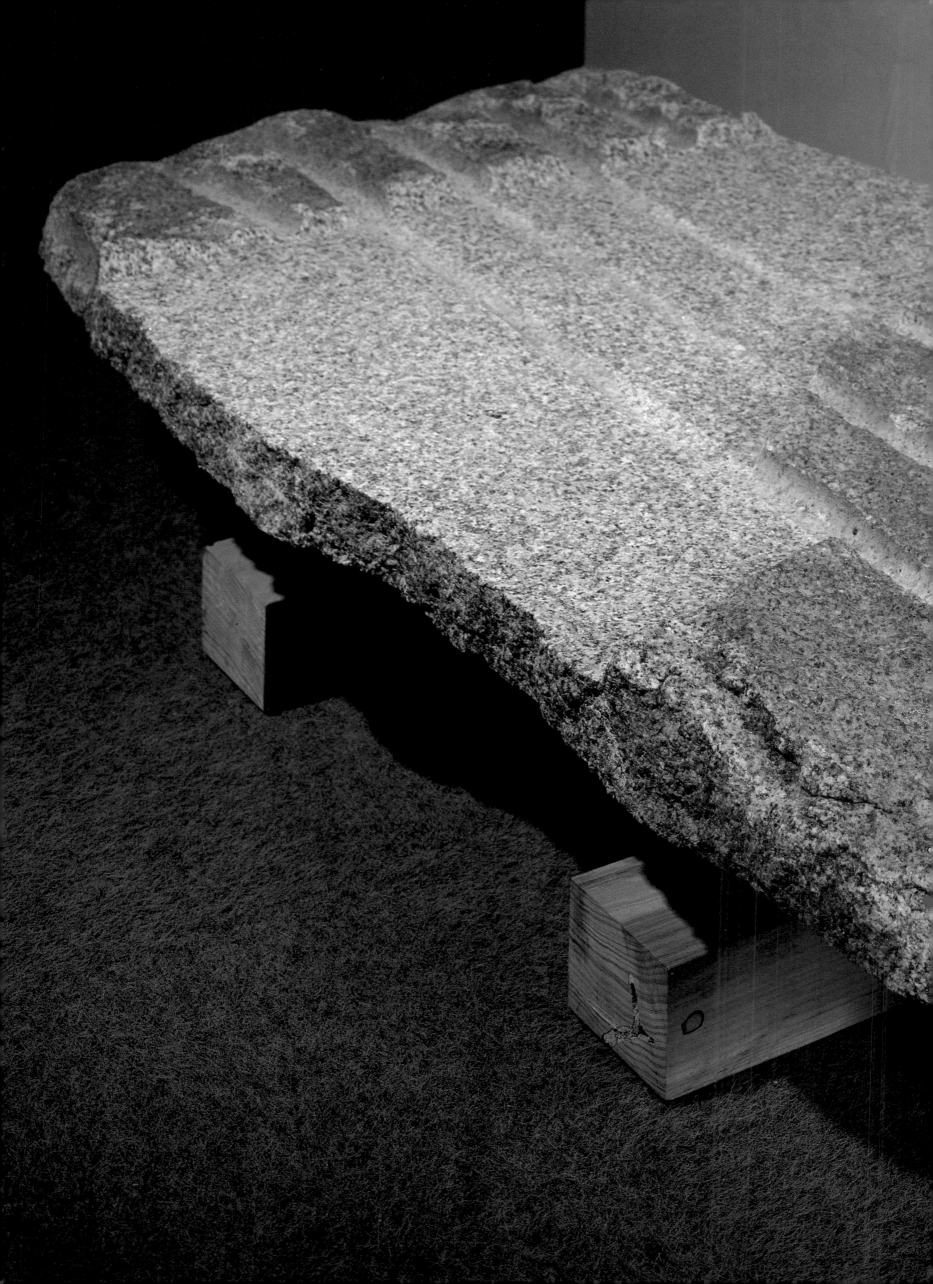

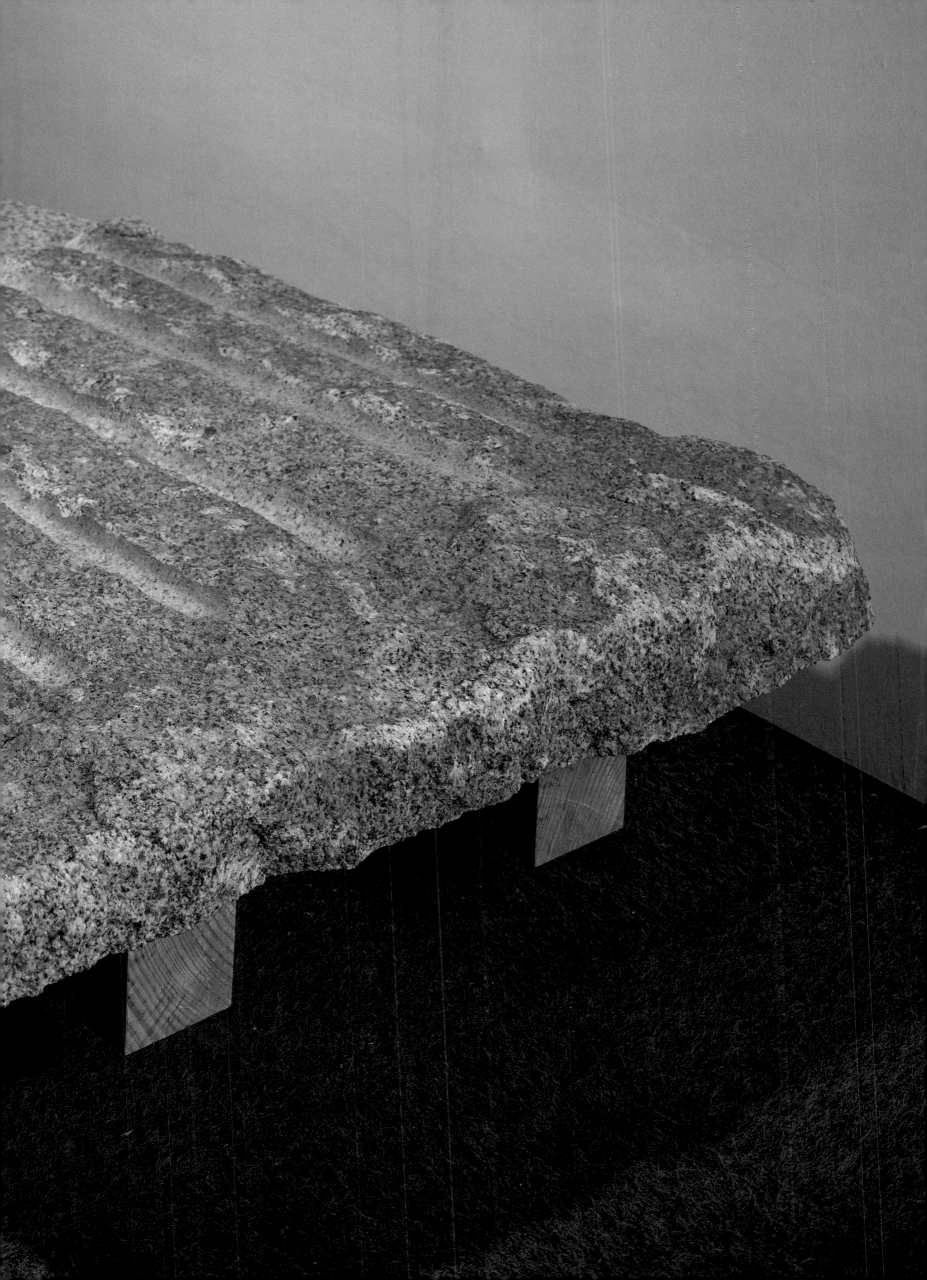

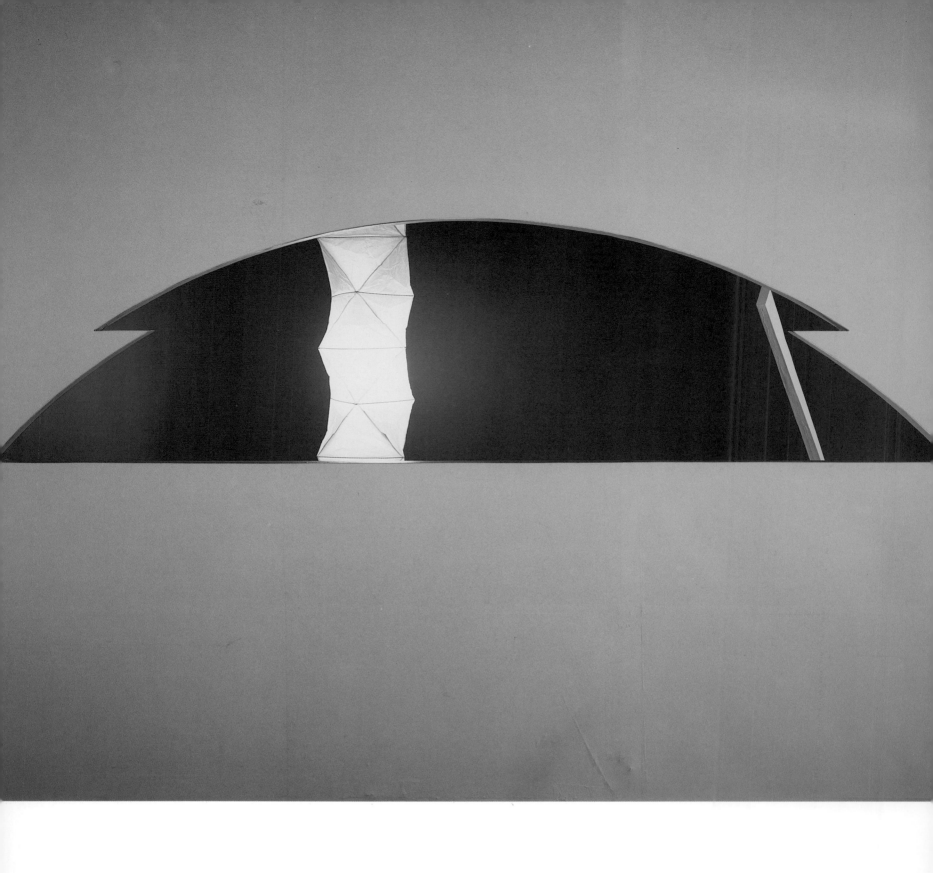

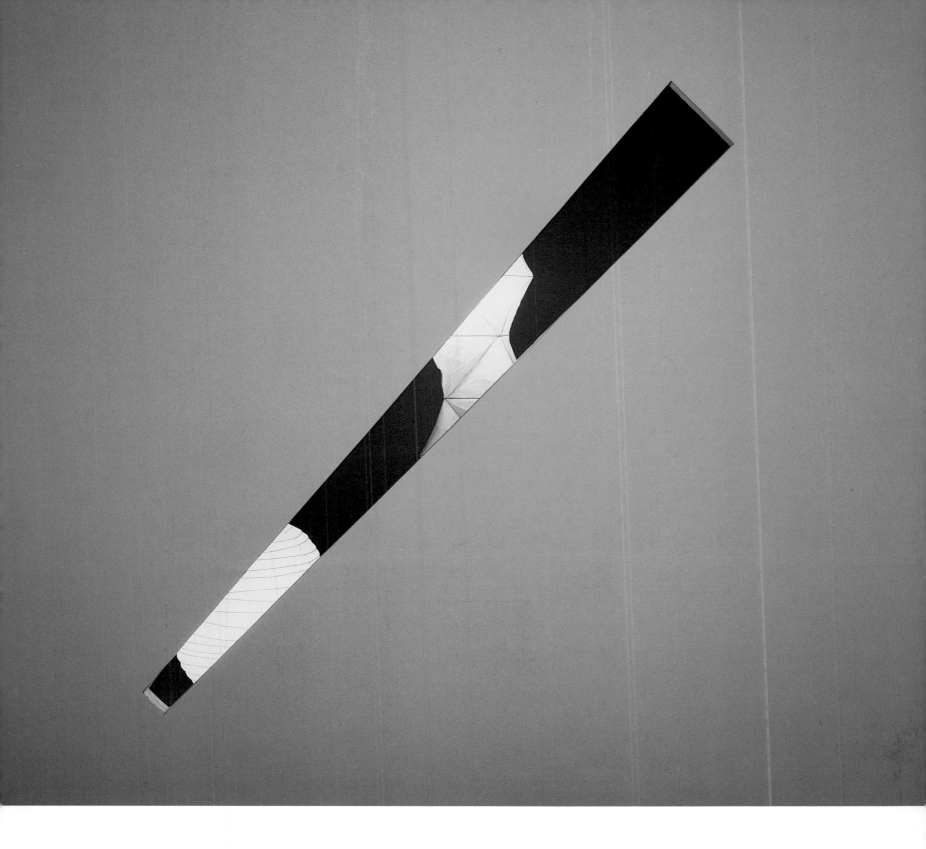

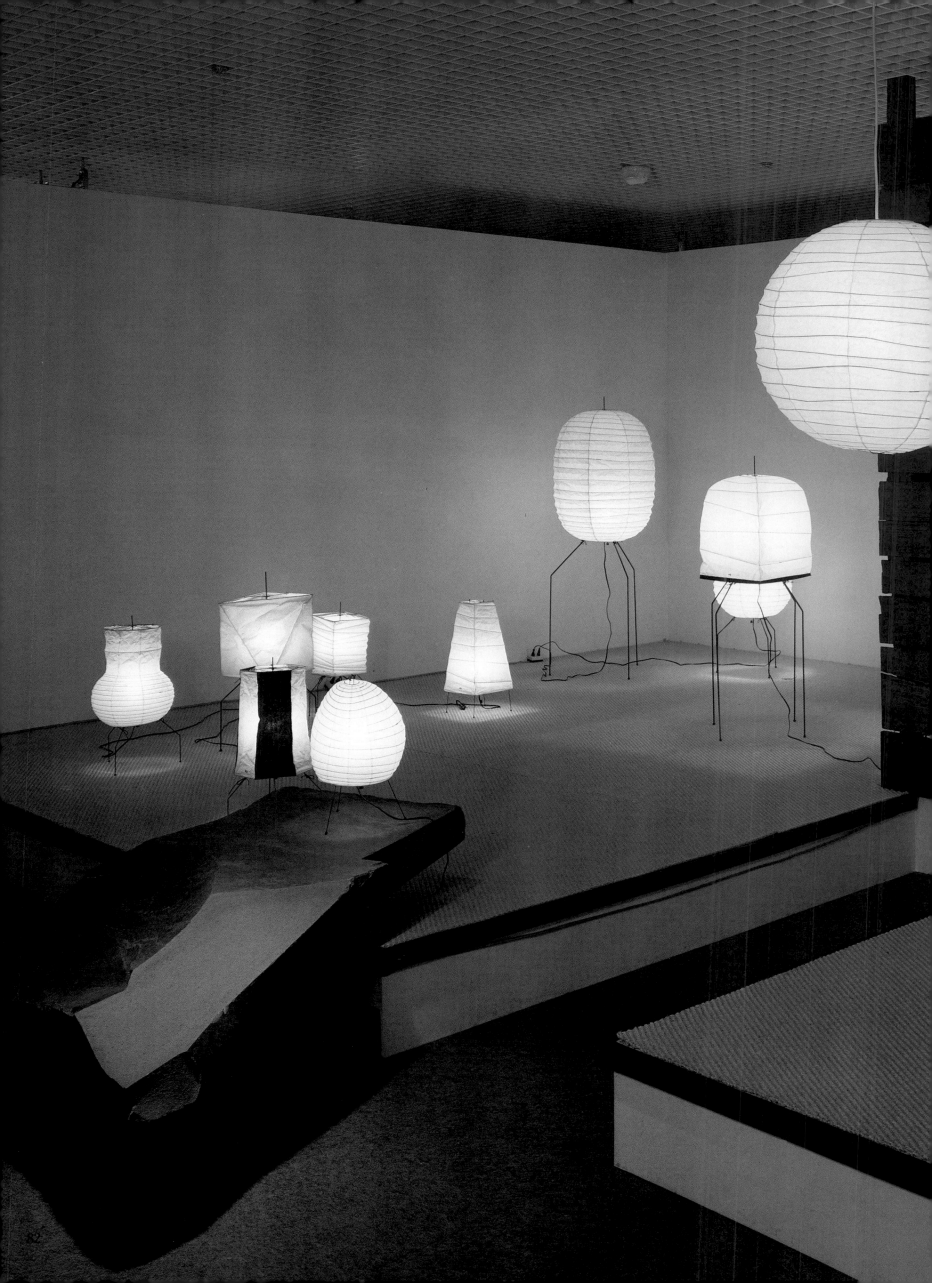

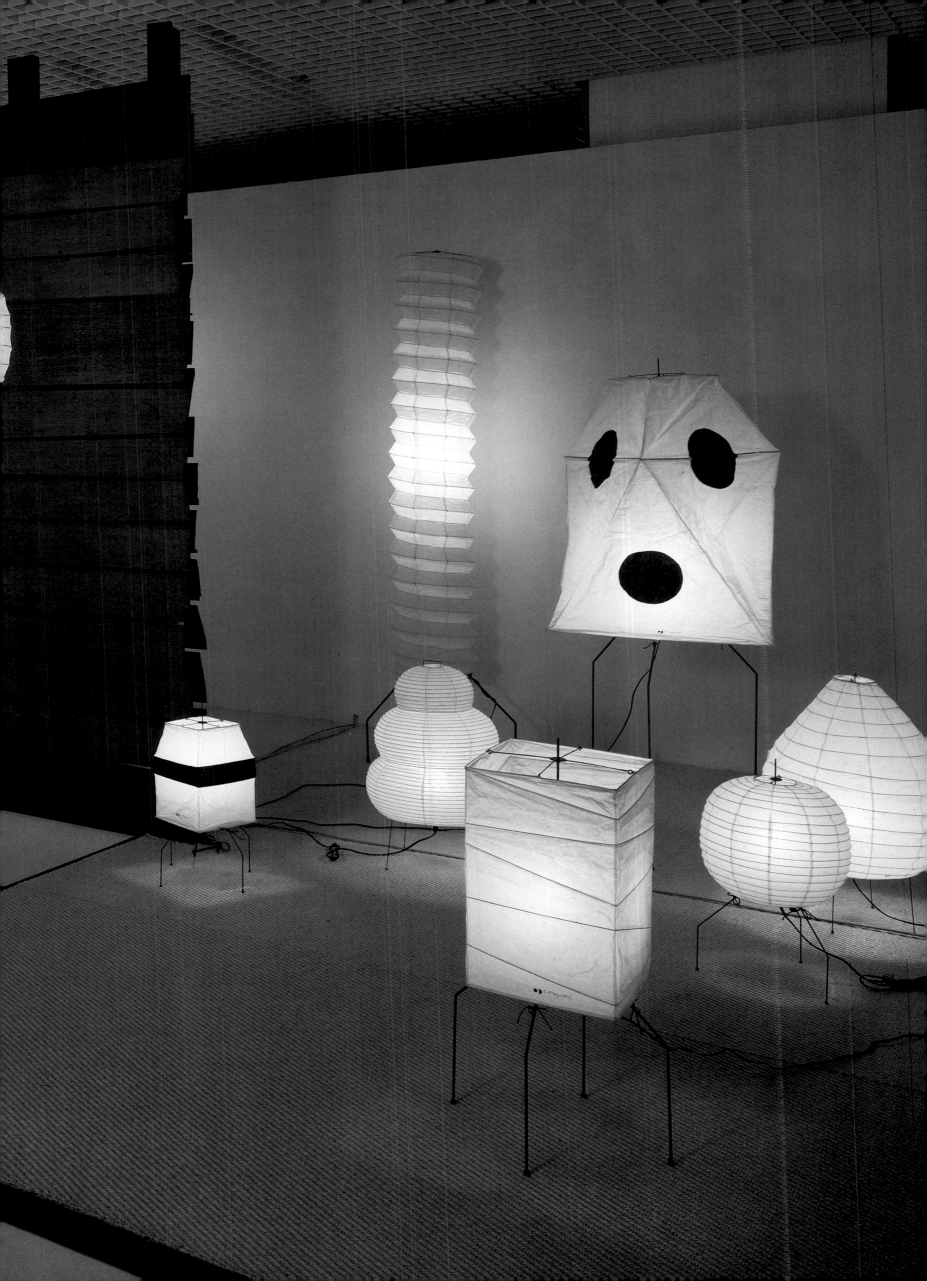

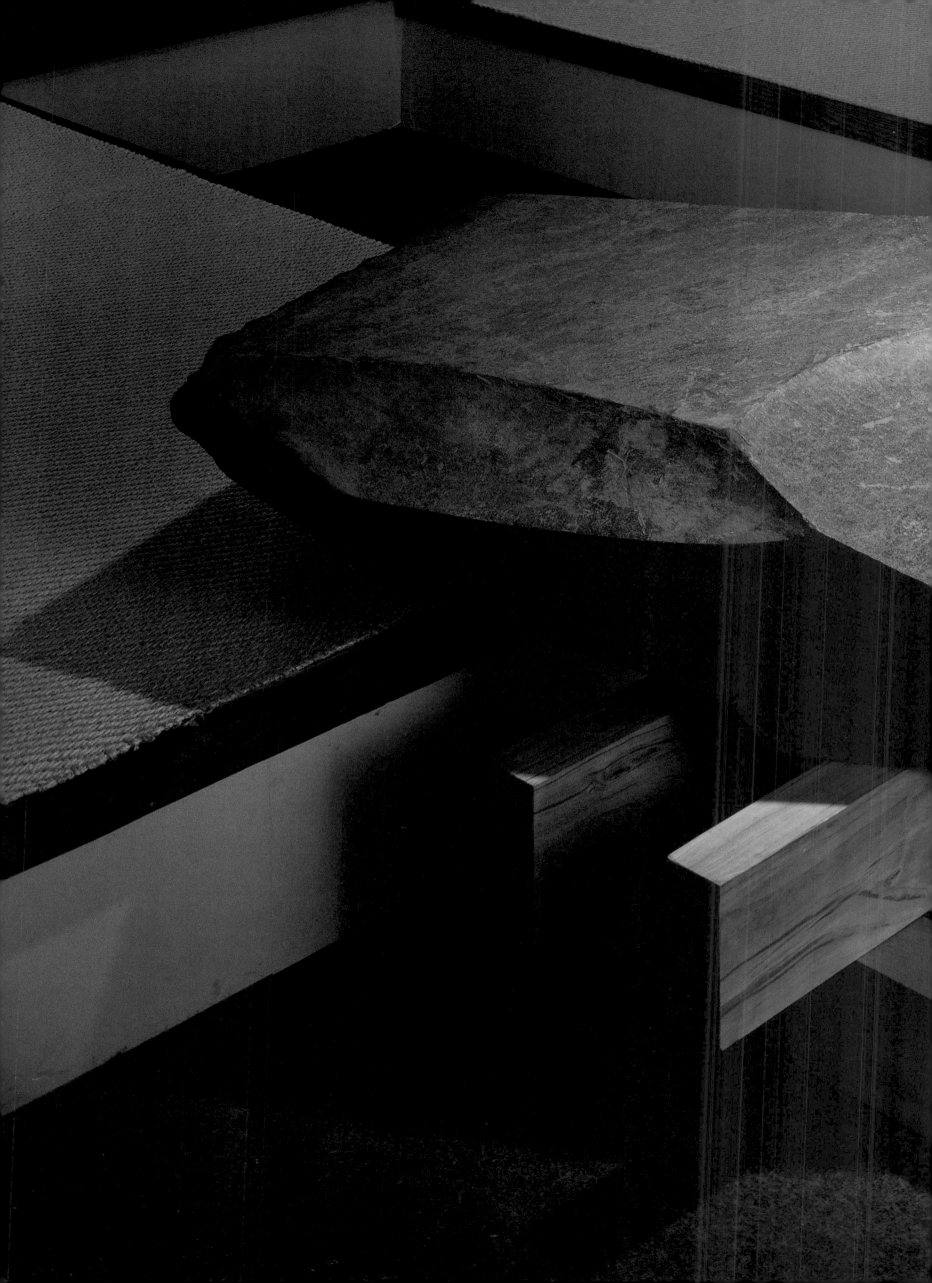

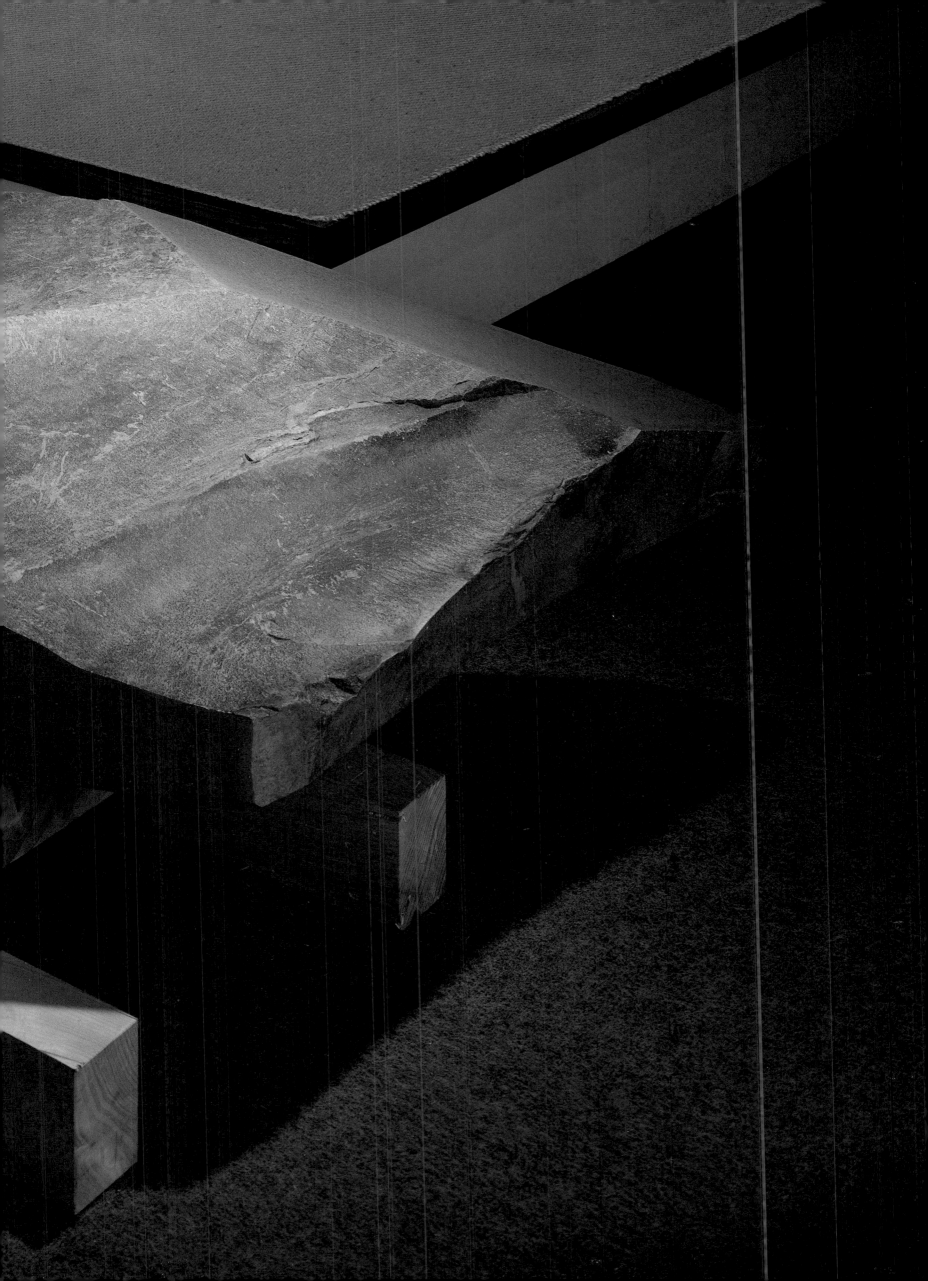

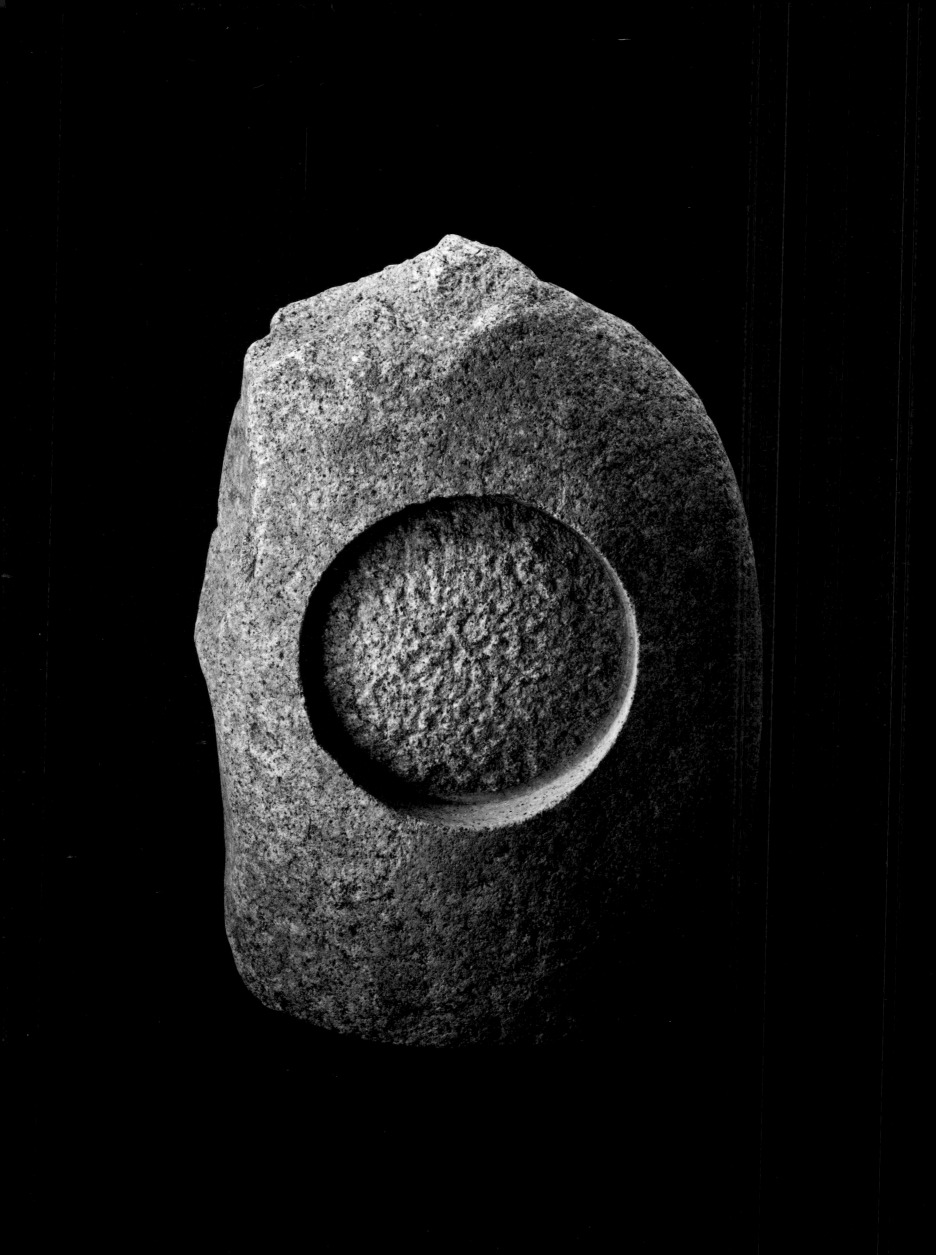

ISAMU NOGUCHI EXHIBIT／SPACE OF AKARI AND STONE　Date: Feb. 9–20 (Closed thursdays)
Place:Yurakucho Art Forum　7th Floor Yurakucho Seibu　Organized by: The Seibu Museum of Art
Installation design by: Arata Isozaki　Special Assistance by: Hiroshi Teshigawara

イサムノグチ展

あかりと石の空間

1985年2月9日㊏—20日㊌　有楽町西武7階
木曜休館

有楽町アート・フォーラム

主催＝西武美術館

インスタレーション＝磯崎 新　協力＝勅使河原宏

入場料＝一般500円(300円)／学生300円(200円)

(　)内は前売・団体20名以上料金

Graphic design by Ikko Tanaka

SEIBU
西武

有楽町

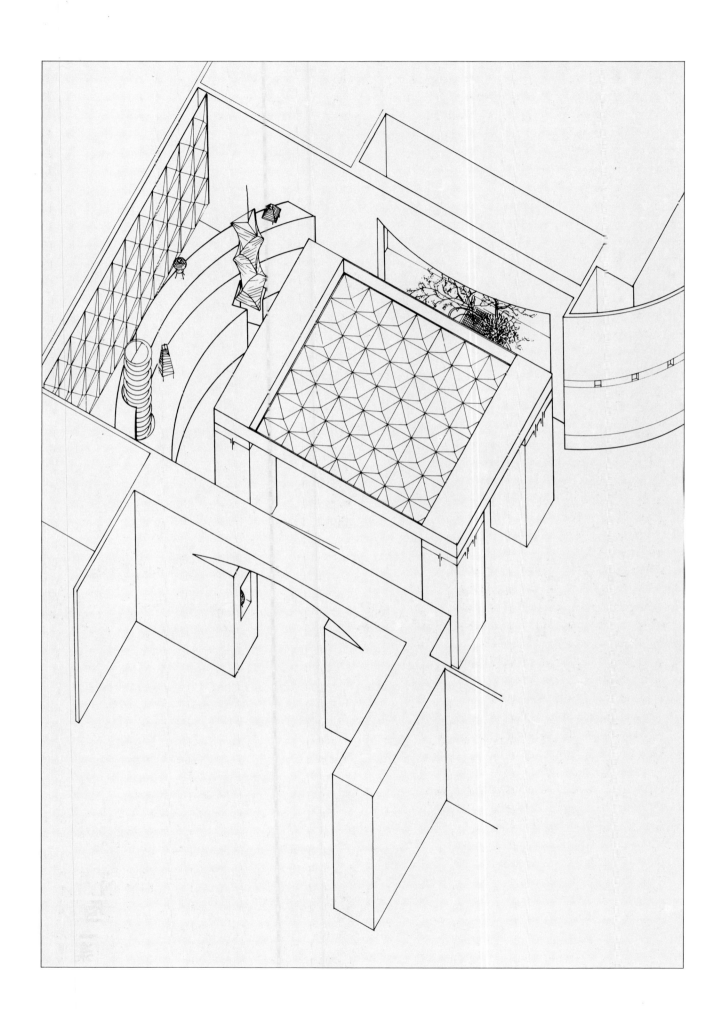

To Envision a Living Space

The Isamu Noguchi Exhibition Installation

Arata Isozaki

Some thirty years ago, after graduating university, found me apprenticing under Kenzō Tange. It was around that time I first laid eyes on Isamu Noguchi. He was designing bridge railings for Tange's Hiroshima Peace Park, then mid-construction, and thus occasioned to frequent our Hongo-area Tokyo offices. I again had the opportunity to see his work when laying out his gardens for the UNESCO Headquarters in Paris, a project that entailed drafting up many plans, for which I did some of the trace work.

At last the chance came to be on hand as one entire project, his fountains for the grounds of Expo '70 in Osaka, took shape from conception to realization. Sure enough, a veritable fountain of ideas issued forth—cascading fountains, whirling fountains, upsurging fountains, configurations that defied accepted notions of hydrodynamics—all bearing the stamp of Isamu's distinctive sculptural genius. My own tasks did not allow me to remain constantly by the pond site where these fountains were being set up, yet the prodigious efforts of this wizard Isamu never failed to astound me and elicit admiration.

Somehow, whenever I see Isamu, I get the impression he's perpetually busy at work. His ideas seem to keep him on the run, springing up one after the next, with never enough time to work them all through to completion with his own hands. For instance, on visiting the exhibition area of his new museum slated for opening this May on the banks of the East River, Isamu appeared on the scene from his workshop nearby, having barely managed to put aside his activities long enough to show us around. And as soon as the tour was over, he immediately went back to his workshop. There could hardly be a more striking contrast to someone like Picasso, who amidst whatever activity always contrived to look as if he'd just dragged himself out of bed to meet you. Perhaps it is that Isamu is continually gauging the amount of work he still has to do. He approaches each undertaking with the forthright application of a Buddhist trainee. So that by now, his aspect has taken on the eminence of an elder priest.

This past autumn Isamu celebrated his eightieth birthday. An incredibly diverse group of faces got together for the occasion, attesting to the breadth of his acquaintances. The gathering was held at the Sōgetsu Kaikan, concurrent with an exhibition of recent stone sculptures and a series of his Akari lamps on new stands. The stone sculptures were amazingly free in execution, with just the precise minimum of carving into the natural stone; cutting-edge works that impressed one and all as signalling an "arrival" at a yet higher new level of creation.

The present *Stone and Light Space* exhibition seems to have grown out of ideas that came to him around that time. The following day he contacted me, and I paid him a visit at his customary Tokyo lodgings at the Fukudaya Inn in Yotsuya. I recalled how just the previous night at the exhibition hall he had expressed the desire to "display Akari lamps in a wholly different way than ever before," to which I could only mutter to myself, now this is something I had to see. For up to that point I had seen a number of exhibitions of his lighting designs, not to mention his many showrooms. And all without exception had left me with the same impression: so many "*bombori* lamps" together in one place created an unearthly atmosphere of subtle filtered light that held nothing but associations with *Obon*, the Buddhist "Festival of the Dead," when the returning souls of long deceased ancestors were traditionally greeted with strings of paper lanterns. Hence wholly apart from any consideration of designs better or worse, I inevitably found his lighting displays saddled with somewhat distasteful overtones.

That day, predictably, hard-working Isamu had been at it since early morning. He had produced a poetic piece of writing, which he presently handed over to me, saying "Here's what I wrote, see what you can do with it." His words, reproduced on page 14 of this book, seemed truer to the image of the show than any abstruse theorizing could ever have been.

My job, then, was to transpose that poetic image into concrete form. That is, to place the hundred plus

Akari lamps in various situations; to create a unique atmosphere by bringing these lights into juxtaposition with walls, floor, columns, textures, and other elements. I found a convenient source reference for this in the Shōkintei arbor of the Katsura Detached Palace. For as soon as I learned how closely the layout of the Shōkintei matched that of the exhibition space, I set about directly utilizing that plan to derive units of spatial division. Naturally, the overall scheme had to mirror the lake and gardens surrounding the original arbor. For the lake I brought in Nachi *kuroishi* stones, and actually spread out a sheet of water. Where the garden faded into the mist, I draped curtains of sheer gauze.

Around that I created an environment of stone and metal. But since real stone would have been impossible to install in only two nights, I improvised with rough mortar. Next, translucent grid netting and punched metal sheets were layered over a backdrop of ordinary corrugated zinc, with a zinc-plated box sandwiched in between these two sections. All were left unpainted. The actual structure of the Shōkintei arbor served only to set the spatial dimensions; most other particulars were dissolved, leaving only the basic plan indicated in approximate outline by a scaffolding of rough timbers.

The use of the Ichimatsu "checkerboard" from the *tokonoma* alcove and *fusuma* sliding doors of the Shōkintei arbor likewise remained consistent, although the wall surfacing and flooring materials underwent thorough change. *Chamaku* tearoom walls were converted to a "Mondrian pattern." Then there was a *muro* "storeroom" with bright red interior walls; an eight-*tatami*-mat room faced with *kakishibu-gami* persimmon-tannin paper, and wholly occupied by an enormous Akari lamp two meters across; a vertical window-grating backed with a *tsumugi* pongee fabric. All in a conscious effort to alter the backdrop walls as much as possible.

I was given two weeks to work up plans, and once I'd drafted preliminary sketches, I set out for Isamu's studio in Takamatsu on the island of Shikoku. Up to that point it was to have been an exhibition solely of Akari lamps, but as soon as I arrived at the airport, Isamu led me straight away to a display of his stone sculptures. As it turned out, he was working on still a few more pieces, as yet lying on their sides unfinished, for last-minute inclusion in the exhibition.

Then and there it was decided to make this an exhibition of both stone sculptures and Akari lamps. Ultimately, he added two free-standing upright stone sculptures included in the previous Sōgetsu Kaikan showing, for a total of fourteen pieces. That made all of twelve pieces he produced in little over two months.

The prospect of handling such diametric elements presented further difficulties: how to go about "situating" the hard, dense weight of stone together with the soft, airy buoyancy of paper? How to envision a space simultaneously receptive to cool, light-absorbing masses of stone and warm, light-emitting forms in paper? Such questions, of course, are all part of what makes Isamu's art so demanding and so rewarding. And truly, the introduction of stone sculptures into the "stage setting" tentatively created for a lighting show did work to complete the environment, to fill it with a commanding presence.

Plans had also been made for Hiroshi Teshigahara of the Sōgetsu school of *ikebana* to arrange flowers for the exhibition, when complications arose. It seems that right up to the one night allotted for doing the arrangement, he had to be in Hong Kong. Fortunately, however, the same day had him in transit to Taipei. Thus altering his itinerary to bring him through Tokyo, the feat was accomplished; a return trip just to give some three hours of attention to our flower arrangement.

Once the flowers were arranged and in place, the exhibition area not only came alive with color, but it all pulled together. Moreover, it clearly highlighted the interrelationship between architecture and sculpture as fixed, enduring statements and *ikebana* as a thing of the moment. The exhibition was to run a mere two weeks, yet even for a temporary "stage setting" the degree of coherence was impressive.

For someone like me, who is accustomed to working exclusively on long-term projects, the realization of this short-lived installation had something of the impromptu spirit of entertaining a bird that just happened by. It required light footwork. Quick turnabouts. But above all, it was the opportunity to work with Isamu that I shall remember most fondly. The exhibition area installation is now gone, yet it has come to mean more and more to me.

The Meaning of Akari Isamu Noguchi

When Seibu kindly proposed to show AKARI in Yurakucho, I immediately reacted with delight that this might be presented as a display of the universality of their use. No one could have responded to this challenge with more ability and imagination than Arata Isozaki. I am grateful to him for having created a remarkable meeting of East and West, past, present, and into the future—where all dichotomies will finally dissolve into harmony with their common link of AKARI.

Since their birth thirty-three years ago, AKARI have continued to grow in use throughout the world as a source of light and as an object of art that seems to fit into any environment. It may be said that an art that has gained such status of familiarity must influence the way of life. For poor or rich they are a mark of sensibility, not of status, but as an accent of quality, giving light to whatever may be our world. Of East or West, classical or modern, nothing is too elegant or too dismal not to be enhanced. It has been said that to start a home all that is needed is a room, a pad and AKARI.

List of Works

p.17 —— Entrance: Stone environment with modular Akari ceiling, *Personage I*, 1984 (andesite, 169 × 40 × 32 cm) and ikebana by Hiroshi Teshigahara.

pp.18-19 —— Stone environment.

pp.20-21 —— *Resonance*, 1985 (andesite, 176 × 50 × 25 cm).

pp.22-23 —— Garden and pond environment with *Resonance* (foreground) and *Far Land*, *Phoenix I* and *Kyokosan* (background l. to r.).

p.24 —— *Phoenix I*, 1984 (granite, 123 × 68 × 50 cm).

pp.25, 26-27 —— *Far Land*, 1985 (andesite, 187 × 106 × 20 cm).

p.28 —— Akari UF4-31N, UF5-31NW.

p.29 —— Akari UF3-S.

pp.30-31 —— Garden and pond environment with Akari UF3-XN, UF4-L5, 23N, UF3-L6, UF5-31NW, J1 and UF4-L6 (l. to r.), *Far Land* and *Phoenix I* (l. to r.).

p.32 —— Akari UF1-FF.

p.33 —— Akari UF1-S and *Lap*, 1985 (basalt, 117 × 73 × 10 cm).

p.34 —— Akari UF3-Q.

p.35 —— Akari UF2-31N.

pp.36-37, 38, 39 —— *Inkstone*, 1984 (granite, 103 × 64 × 7 cm).

p.40 —— Shokintei environment with *Kyokosan*, 1984 (andesite, 162 × 55 × 30 cm) (foreground), *Lap* and *Rice Field* (middle ground l. to r.), *Inkstone* and *Transformation of Nature I* (background l. to r.).

p.41 —— Akari 3X and *Transformation of Nature I*, 1985 (andesite, 175 × 85 × 45 cm).

pp.42-43 —— *Transformation of Nature I*.

pp.44-45 —— Shokintei environment with Akari UF4-L6, UF1-S, K1 + BB2, UF5-L4, 33S, 1-AG, L8 (l. to r.) and *Inkstone* (foreground).

p.46 —— Akari UF4-L5.

p.47 —— Akari UF4-L8, UF5-33NW, UF4-L6, UF4-L5 and UF4-31N (l. to r.).

p.48 —— Shokintei environment.

pp.49, 50-51 —— *Rice Field*, 1984 (granite, 130 × 73 × 15 cm).

pp.52-53 —— Window grating environment with Akari 40-XP, ceramic vase by Noguchi and ikebana by Hiroshi Teshigahara.

pp.54-55 —— Akari 2 meters in diameter.

p.56 —— Mondrian pattern tea room with Akari UF4-33N and 1P (l. to r.).

p.57 —— Akari UF5-32N.

pp.58-59 —— *Phoenix II*, 1984 (granite, 112 × 38 × 24 cm).

p.60 —— Akari UF3-XN, UF3-S and UF3-DL (l. to r.).

p.61 —— Akari UF1-XN, UF3-XN and UF2-X (l. to r.).

pp.62-63 —— Mondrian pattern tea room.

pp.64, 65 —— *Woman*, 1984 (granite, 94 × 60 × 50 cm).

pp.66-67 —— Punched metal sheet environment with Akari UF2-31N, 31N, 2P (l. to r.) and *Woman*.

pp.68-69 —— Akari UF1-FF, UF2-FF, UF1-XN, UF2-U, UF2-31N and UF3-U (l. to r.).

pp.70-71 —— Grid netting environment with Akari YP-1, 26N, 25N, 45X and UF5-32N (l. to r.).

p.72 —— Akari UF2-U, UF2-H, UF3-H and UF3-U (l. to r.).

p.73 —— Grid netting environment.

pp.74-75 —— Zinc-plated box environment with Akari YA-2 and UF2-Y (l. to r.).

p.76 —— Red storeroom and Akari display with *River Mouth*, 1984 (granite, 130 × 74 × 9 cm).

p.77 —— Akari display.

pp.78-79 —— *River Mouth*.

pp.80, 81 —— Red storeroom.

pp.82-83 —— Akari display with *Transformation of Nature II*, 1985 (andesite, 152 × 86 × 26 cm).

pp.84-85 —— *Transformation of Nature II*.

pp.86, 87 —— *Ojizousama*, 1985 (andesite, 46 × 31 × 14 cm).

p.88 —— Exhibition poster by Ikko Tanaka.

p.89 —— Isometric drawing of entrance and stone environment by Arata Isozaki.

p.102 —— Floor plan of exhibition by Arata Isozaki.

Chronology ——————————————————————————————

1904 —— Born in Los Angeles, son of poet Yonejiro Noguchi and writer, teacher Leonie Gilmour.

1906 —— Noguchi family moves to Tokyo.

1918 —— Isamu is sent alone to school in America.

1922 —— Graduating from High School, Isamu decides to become an artist, begins studies under the sculptor Gutzon Borglum.

1922-24 — Decides against art and enters Columbia Medical School.

1924 —— Begins again the study of sculpturing at the Leonardo da Vinci Art School in New York. Opens a studio in Greenwich Village. Chosen as a member of the National Sculpture Society.

1926 —— Transfixed by Brancusi's sculptures in the New York Brummer Gallery.

1927 —— Travels to Paris on a Guggenheim Scholarship. Works in Brancusi's studio.

1928 —— Returns to New York to hold an exhibition at the Eugene Schoen Gallery.

1930-31 — Returns to Paris. Travels in China and studies brush drawing techniques under Chi Pai Shi. Visits Tokyo and studies ceramics.

1935 —— Begins set designs for Martha Graham's dance performances.

1935-36 — Completes first major work, "History Mexico" in Mexico's Albelardo Rodriguez Market.

1938 —— Wins first place in relief competition with a stainless steel work at the Rockefeller Center.

1949-50 — Receives grant from Bollingen Foundation, travels to Europe, Egypt, India, and Japan. Holds an exhibition at Mitsukoshi Department Store.

1951-52 — Designs garden for Keio University and 2 bridges for Hiroshima.

1953 —— Holds exhibition in Museum of Modern Art, Kanagawa.

1956-58 — Designs garden for Paris Unesco Building.

1960-64 — Designs marble garden for Yale University Library.

1960-65 — Designs sculpture garden for Jerusalem National Museum.

1961 —— Establishes Long Island City studio.

1968 —— Retrospective exhibition at Whitney Museum.

1970 —— Designs fountain for Expo '70, Osaka.

1972 —— Exhibition of marble sculptures a Gimpel Fils Gallery, London and Zurich.

1973 —— Exhibition at Minami Gallery, Tokyo.

1974 —— Exhibits works in the Guggenheim Museum's exhibition, "Masters of Modern Sculpture." Designs fountain for Detroit Civic Center.

1976 —— Exhibits work in Whitney Museum Exhibition, "200 years of American Sculpture."

1977 —— Designs fountain for Chicago Art Institute. Designs rock garden for the lobby of the Sogetsu Plaza, Tokyo. Exhibition at the New York Museum of Modern Art.

1978 —— Holds "Imaginary Landscapes" exhibition at Walker Art Center, Minneapolis.

1980 —— "Isamu Noguchi" exhibition held to commemorate the Whitney Museum's 50th anniversary. The Emmerich and Pace Galleries hold Isamu Noguchi's 75th birthday exhibition.

1982 —— Designs "California Scenario" garden in California. Completes 26 steel sculptures in California.

1983 —— Establishes Garden Museum at Long Island City studio, New York.
Designs plaza for Little Tokyo in Los Angeles.
26 Galvanized steel sculptures show held at Gallery Kasahara and Gallery Yamaguchi, Osaka.

1984 —— Finishes "Lightning Bolt" memorial to Benjamin Franklin at the Ben Franklin Bridge in Philadelphia.
Galvanized steel sculptures show travels to Gallery Suzukawa, Hiroshima(February); Sogetsu Plaza, Tokyo(April); Basket Park Base, Oita(November). Sogetsu Art Gallery holds Isamu Noguchi's 80th birthday exhibition.

1985 —— "Isamu Noguchi—Stones" exhibit held at Gallery Kasahara in Osaka. Yurakucho Seibu in Tokyo hosts "Isamu Noguchi—The Space of Akari and Stone" exhibit. Official opening of the Isamu Noguchi Garden Museum in Long Island City. Named to represent the U.S.A. at the 1986 Venice Biennale.

Arata Isozaki

Arata Isozaki was born in Oita City in 1931. After graduating from the Architectural Faculty of Tokyo University in 1954, he joined Kenzo Tange's Team URTEC working until 1963 when he started his own firm. From 1966 to 1970 he was engaged in the site planning and other architectural concerns related to Expo '70 in Osaka, Japan. Other major projects include the Oita Prefectural Library (1962-66), Gunma Prefectural Museum of Fine Arts (1971-74) Kitakyushu City Museum of Art (1972-74), Kitakyushu Central Library (1973-75), and the Tsukuba Center Building (1978-83). Isozaki was the principal organizer of the exhibit "MA Espace-Temps an Japon" at the Festival d'Automne in Paris, 1978. Since 1981 Isozaki has been working on the permanent home for the Museum of Contemporary Art in Los Angeles and since 1983 on the Barcelona Sports Hall for the proposed 1992 Olympic Games in Barcelona, Spain. In 1985 Isozaki completed work on the renovation of the Palladium Club in New York City. In addition to his design work, Isozaki has lectured extensively around the world and served as visiting professor at UCLA, RISD, Columbia, Harvard and Yale. The author of numerous books, Isozaki has also served as a juror for various international architectural competitions, including the Pritzker Prize.

Hiroshi Teshigahara

Hiroshi Teshigahara was born on 28 January 1927, the eldest son of Sofu, founder of the Sogetsu School. From the earliest days of his childhood, his father's fresh and original Ikebana was always close at hand. Early on, he manifested an interest in painting, and studied it at university. In the sixties he found his own mode of self expression in films, and made an international name for himself as a director. His excellent and highly individual films were shown world-wide. Outstanding among them was "The Woman in the Dunes," which received many awards overseas as well as at home, including the jury's special award at the Cannes Film Festival. It is still frequently revived today.

He was inspired by ceramics in the seventies, and in 1973 established the Sogetsu Tobo Kiln at Miyazaki-Mura, Fukui Prefecture, where he devoted himself to producing original vases and ceramic objects uninhibited by tradition. Since succeeding to the position of headmaster (*iemoto*) of the Sogetsu School in 1980, he has been seeking through his many excellent works to explore the outer limits of Ikebana, defined as an art form based on the use of plant materials.

Ikko Tanaka

Born in Nara in 1930, Ikko Tanaka graduated from the Kyoto City College of Fine Art in 1950. Following positions with the Sankei Newspaper and Nippon Design Center, Tanaka founded his studio in Tokyo in 1963. Often honored and widely exhibited, Tanaka's awards include the 9th JAAC Membership Prize (1959), the Tokyo A.D.C. Gold Medal (1960), Silver Prize at the International Poster Biennale in Warsaw (1968), the Kodansha Publishing Co.'s Publishing Culture Award (1973) and the Mainichi Industrial Design Award (1973). He has also received the Recommended Artist's Award from the Japanese Ministry of Education (1980), Bronze Prize at the International Poster Biennale, Warsaw (1984) and Second Prize at the Sixth Lanti Poster Biennale (1985). Tanaka's credits in exhibition design include the displays of the Japanese Government Pavilion at Expo '70, Osaka and the Oceanic Cultural Museum at Ocean Expo '75, Okinawa, the "Japan Style" exhibit at the Victoria and Albert Museum, London (1980) and "Japan Design—Tradition and Contemporary" exhibit held in Moscow (1984). He has served as the art director for the Seibu Group since 1973.

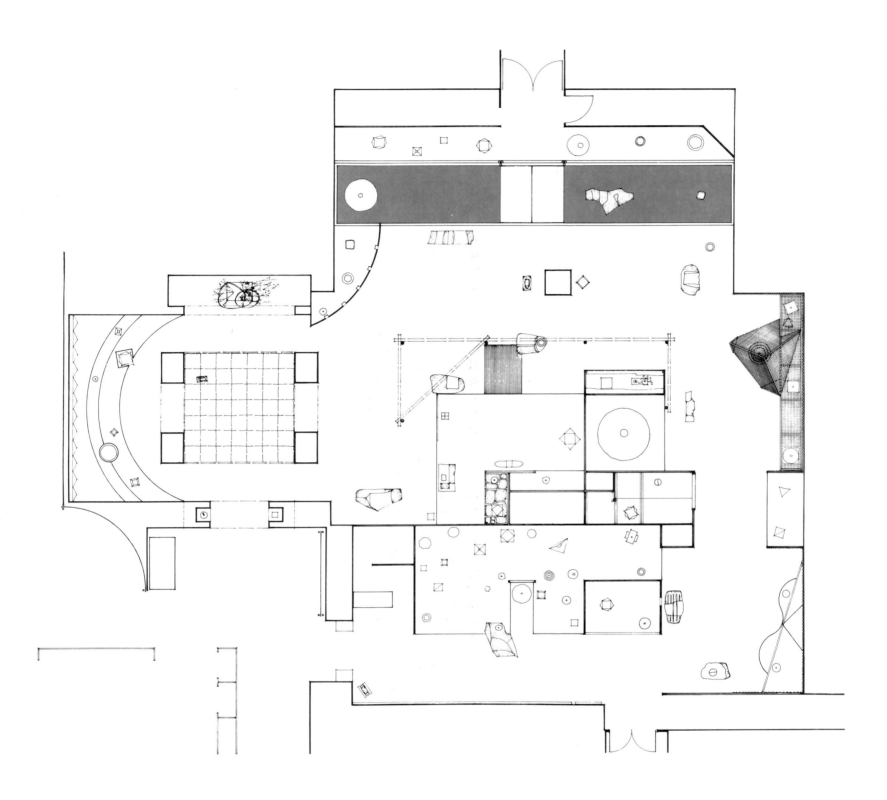

Afterword

Underlying the publication of this book are an interesting set of circumstances which I wish briefly to relate here. Isamu Noguchi has for years been making traditional Japanese "chochin" paper lanterns as modern art AKARI to be used in contemporary living environments. When the newest series of AKARI, the UF series, was completed, Mr. Noguchi and we at Takanawa Art wished to exhibit them as an environmental art. Deciding to hold this exhibition in the new Yurakucho Seibu which opened in 1984, we agreed on Arata Isozaki as the best person to design the installation. With that, Isamu Noguchi wrote the poetic text reproduced on page 14. Taking this for a script, the exhibition composed of sculptures and the most recent AKARI of Isamu Noguchi, installation design by Arata Isozaki, flower arrangement by Hiroshi Teshigahara, and poster by Ikko Tanaka played together as an opera with the new exhibition space called Yurakucho Art Forum as the stage. Alas, this wonderful environment disappeared from view like a dream after two weeks. Consequently we publish this book with a text by Takahiko Okada and photographs by Shigeo Anzai as a record of the exhibition "Isamu Noguchi: Space of AKARI and Stone."

In addition to the contributions already mentioned, we wish to express our special thanks to Masatoshi Izumi, Hidetaro Ozeki and Michio Noguchi and the many others who helped us greatly in assembling this exhibition. Our gratitude goes as well to Ikko Tanaka and Katsuhiro Kinoshita for their efforts in designing this book. In closing, I want to mention that the music of Toru Takemitsu formed a perfect complement to the installation and completed this artful environment.

September 1985
Ken-ichi Kinokuni
Director of
The Seibu Museum of Art